Thinking Photography

by DIANE ASSÉO GRILICHES

MERCER UNIVERSITY PRESS
Macon, Georgia

MUP/ P456

© 2012 Diane Asséo Griliches

Published by
Mercer University Press
1400 Coleman Avenue
Macon, Georgia 31207

First Edition

Visit our website at www.mupress.org

Printed in the United States of America

Book Design by Karen Stein

Books published by Mercer University Press are printed on acid-free paper that meets the requirements
of the American National Standard for Information Sciences—Permanence of Paper for Printed Library Materials.

Mercer University Press is a member of Green Press Initiative (greenpressinitiative.org), a nonprofit
organization working to help publishers and printers increase their use of recycled paper and decrease
their use of fiber derived from endangered forests.

Library of Congress Cataloging-in-Publication Data

Griliches, Diane Asséo, 1931-
 Thinking photography / by Diane Asséo Griliches. -- 1st ed.
 p. cm.
 ISBN 978-0-88146-427-6 (pbk. : alk. paper) -- ISBN 0-88146-427-9 (pbk. : alk. paper)
 1. Photography--Technique. 2. Photographic chemistry. 3. Travel photography. 4. Photography, Artistic. I. Title.
 TR146.G6947 2012
 770--dc23

2012021586

This book is dedicated to those who were so intrigued by the ability
of light to create an image through a hole in a black box on a sensitized surface
that they created the science and the art of photography.
We are all indebted to them for these gifts.
It is hardly possible to imagine our world without photography.

ACKNOWLEDGEMENTS

I thank **Jane Rabb** for her perceptive, constructive, wise and experienced refinements of my text and bibliography which made the relevance and value of words come across with the import and mood they required. It has made all the difference.

It happens, but rarely, that circumstances coincide in such a way that if one is awake to recognize their value and to take advantage of their gifts, one becomes truly blessed. And so I am blessed with the fine work of **Karen Stein** and have had such pleasure in our work together in designing this book and its cover with her skills and creative ideas.

I am so grateful to **Jay Stewart** who has had Capital Offset make the finest prints of my work, and whose experience I have valued from day one. His appreciation for my work, his patience and flexibility have made this project so much easier and a pleasure.

Jeremy Pool, with his wizardry in programming, gave me his Collection Manager program to organize my photos, and from the beginning of this project made the task (with thumbnail images) amazingly more easy.

I am grateful to **Claire Weiss** whose keen and quick observations and good judgment helped catch what this author blithely overlooked or neglected to take into consideration.

I thank **Diane Becker**, whose help with sequencing has been of great value to me.

It was **Pablo Ablanedo** whose thoughtful and poetic musician's soul gives me support with his musical metaphors, understanding well the way I thought to shape the text and images of the book.

And to **Jacques Mairesse** I give thanks for raising and discussing the issue of how one chooses what is the best of one's work, a weighty issue, leading to much reflection but alas, no definitive answers.

A warm thanks to **Syrl Silberman** who continues with her good work to see that this book will travel far and wide for the pleasure of as many as possible.

Photography is magic and a gift of science to the arts. We delight in it but are no longer astonished; we are jaded. We take for granted having some sort of camera in our possession, constantly available, a fact of life today.

But photography really *is* still *magic*!

This book hopes to entice the readers into a state of curiosity and then awareness when viewing what lies within, to reflect on what the action of snapping away means, and to discover what aesthetic and technical elements might add to one's knowledge when making photographs.

So what does aperture, shutter speed, contrast, depth of field, and all *that* have to do with making a good image? Why must anyone even bother to *think* when the digital camera seems to do most of the thinking for us?

But first, to appreciate digital, one should realize what came before the pixilated revolution. Many today will not recognize the words "Silver Halide", and yet know much about digital photography. This Silver Halide is the light sensitive chemical compound that forms the basis of all film photography.

Photography, in its inception in 1839, and for some years afterwards involved suffocating heat in a room or small tent, dangerous mercury fumes, explosive gun cotton, noxious nitric and sulphuric acids, as well as the carrying of heavy equipment, often including breakable glass plates, heavy cameras and tripod, trying to keep thick collodion liquid, and worrying about dust in the field.

We've not had to deal with these difficult (and sometimes fatal) processes, but we should appreciate the passion and drive of those who practiced photography back then, and who helped lead the way to silver paper, store-bought supplies, and the well-ventilated darkroom. As the writer Hans Keilson reflects:

Who knows what thoughts will come to you in such a dark, insulated room, while at the same time you are always conscious of the fact that outside there is light, brightness, day. When you move into the dark the feeling is quite different, you are a different person. You freely choose to remain inside the dark.

And in those hours of effort spent in isolation and darkness, which the photographer Brassai called the "half-real zone", one has expectations, more and more work, and finally the reward of one's creation. "A work of art", Nabokov reportedly said, "detaches you from the world of common travail and leads you into another world altogether."

One can lose all notion of time in photographic work, but whether this time is expended in the darkroom or on the digital image in a light room, creating a photograph begins with the joy of the hunt, the discovery, the capture, and the possible artistic creation that

provides the pleasure and motivation to carry on and share the results with the world. "Can there be anything more desirable than aesthetic bliss?" asks Saul Bellow.

Here we are in this digital age as the gift of science to the arts keeps giving. While the images in this book were made with film, most of the aesthetic and technical elements that created the photographs are available to anyone with a digital camera which still depends on light and lens control.

The digital camera reconfigures an image into a mosaic of millions of changeable pixels. Everything seen is translated into data. This data can be reshuffled infinitely, allowing the photographer to remain ignorant or to become experienced and creative, achieving amazing effects. But notably now, the photograph is not necessarily expected to be trusted, belying the past truism that the camera cannot lie, though legitimacy is still expected in documentary photography.

So will we value work so easily achieved with digital photography, compared to the more involved processes of the past? The darkroom, paper and film are disappearing, now overtaken by numbers. Some, like the writer-photographer Marcel Tournier, express regret that photographers will no longer have the pleasure of the "unique charm of the inverse luminosity that lights up the negative image, and the alchemy in the pans of developing and fixing baths." And while the advantages of instant sharing are obvious, most digital albums, with their staggering amount of images, remain in the womb of the computer, visible, but seldom giving birth to prints.

As for the print, what is the reason for my love of the black-and-white print? The colors of the world around us are what is seen through the viewfinder. But the black-and-white photo can possess an abstract, austere or other-worldly quality. One notices shapes and patterns, the interplay of shadow and light. Black-and-white can isolate the defining characteristics of an image without the distraction of color, accentuate the essentials and provide a dramatic force to the whole; it can also remove the object from the mundane, often better suiting the mood of the subject matter. Within the limits of black-and-white, the photographer can be more creative.

Accompanying the black-and-white prints in this book are also images made with "alternative" processes in photography that have been practiced by a few for many years since the invention of photography. These examples of the older processes include:

Albumen, Salt, Platinum and Van Dyke printing, Mordencage and Cyanotype.

Among the somewhat newer processes included here are:

Solarized and Infrared prints, the Photogram, Hand-painted photographs and Collage.

These "alternative" processes offer intriguing aesthetic satisfactions to the photographer working with a variety of tactile physical materials both inside and outside the darkroom. All are one of a kind. None are exactly reproducible, so that experimentation is half the fun. Additional pleasure is derived from sharing these experiments, which demonstrate the near boundless areas into which photography can wander.

The results of a few of these "alternative" processes can be approximated with the digital system, but most cannot. The necessary chemicals are still available from particular providers.

The selected images in this book comprise the results of years of observation, the gaining of skills and competence, the digesting of other photographers' creativity, of struggle with the materials, exploration, experimentation, discovery, frustration, self-criticism, and revelation.

The following quotation of Winston Churchill has for years occupied a prominent place on my darkroom wall: "Success is going from failure to failure without loss of enthusiasm." While learning from failure, one gains momentum and the enjoyment of presenting the best of one's efforts, for art wants to be shared. And how are the best selected? To know how to discard is a sobering but profitable exercise. We have a narcissistic attachment to our own work which needs to be attenuated with careful, critical and intuitive selection, the best given a rightful place, and the rest gently or ruthlessly selected out for the dust bin, invented to hold what is not to be preserved. On the other hand, our opinion of our images can change over time, so we keep those thousands of negatives—just in case.

Since photography is often an interactive venture, usually cooperative and occasionally confrontational, a few comments accompanying some images refer to the effect of the approach on both the subject and on the photographer: what approaches help make a good image, leaving a subject with his dignity without violating social decency, intimidating a subject, or making him feel "used"?

The photographer may also experience conflicting feelings during his work. In discussing his cameras, Gordon Parks talked about "a choice of weapons". Brassai talked about photographers being "a pack of crooks, thieves and voyeurs, hoarders of stolen goods". Indeed the camera captures what it sees, and the one doing the "shooting" is transferring an exposure of the seen image to the mysterious innards of this instrument. The subjects do remain in the camera, and we possess what is photographed. "Art is theft. Art is armed robbery" says Janet Malcolm. Samuel Butler expresses it this way: "There is a photographer in every bush, going about like a roaring lion seeking whom he may devour." No doubt the photographer is greedy to possess what was seen. And often we work secretly. Is it voyeurism, honest curiosity, artistry? Possibly all of these impulses.

The selected images here demonstrate some of the many elements of photography as an art, and how one practitioner goes about her work, using the eye, the mind and the heart when making that click of the shutter. Steven Sondheim says that all art is an education.

We enjoy visual communication. We walk through the world observing, taking in sights, and we can ask ourselves why we want a particular image to enter our marvelous machines in order to retain it for ourselves and for others. Since everyone takes photos, why not think about how one goes about it? This book is meant to help the reader enjoy the process as well.

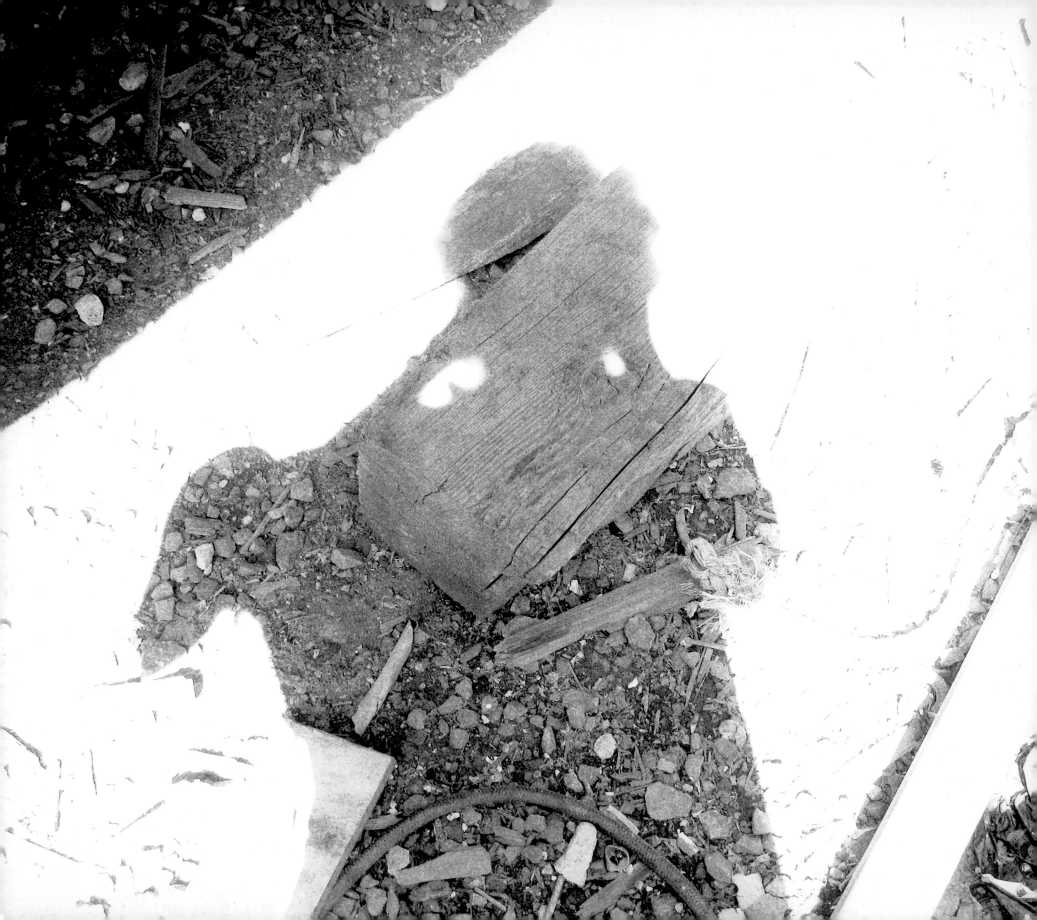

THE PHOTOGRAPHS

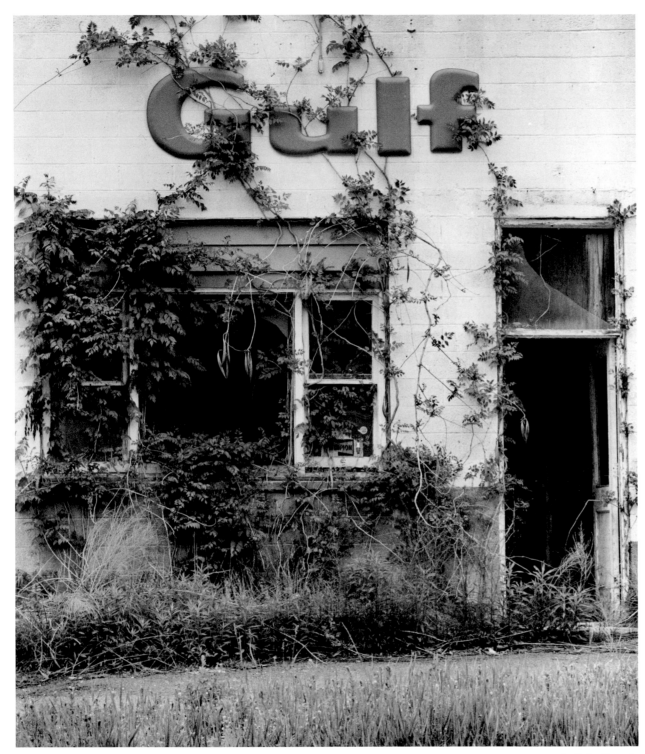

South Carolina 1989

What is it about abandoned places that appeals to photographers?

Why are photographers' imaginations drawn to bleak, humble, decrepit and overgrown places with an atmosphere of a past life, as well as to objects that have no further use, that no one wants anymore? To imagine life as it once was? Is there a special beauty in the darkness of decay, or in the textures and shapes of time's work? Perhaps such mortality frees one to create a photographic immortality. Yet the vines are intensely and aggressively alive!

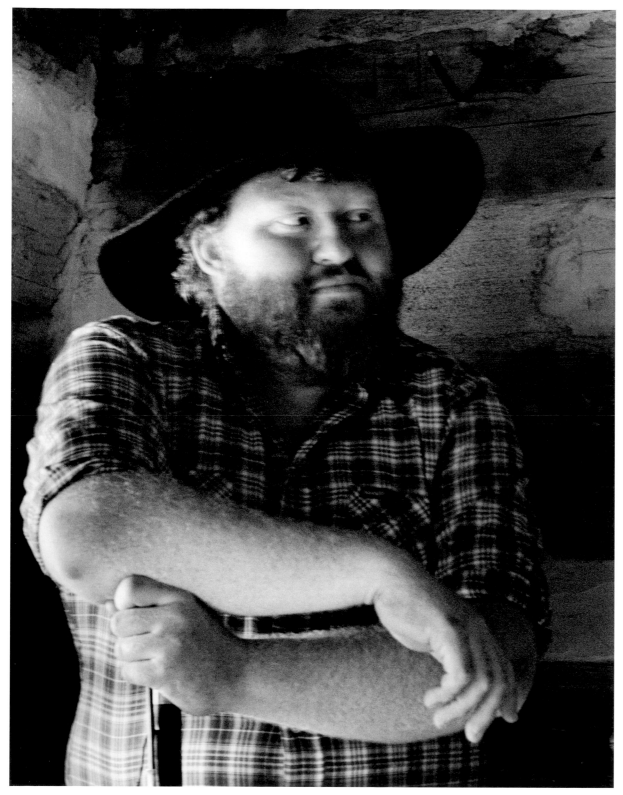

A subject perfect for a Rembrandt portrait when one takes advantage and gains control of the light.

Jerry Vencil, a gentle Appalachian story-teller, is placed by the window to bring the sun's natural illumination to his rough-hewn features.

Lebanon, Virginia 1989

3

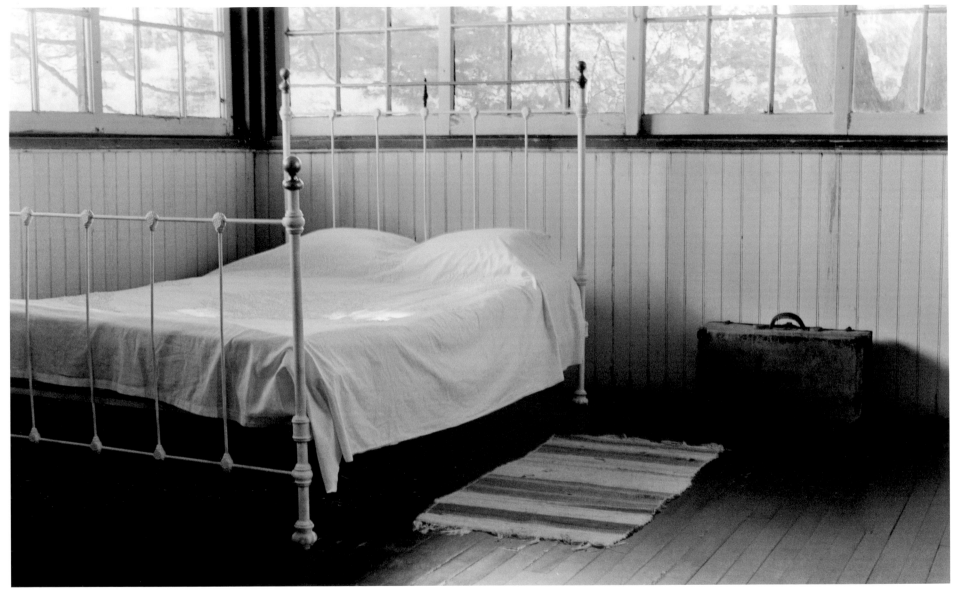

Ashville, North Carolina 1989

Thomas Wolfe himself slept here, in his mother's boarding house, as he wrote in **Look Homeward Angel**: *"Eugene paused, then mounted softly the carpeted stair, so he would not be heard, entering at the top of the landing the sleeping porch on which he slept."*

The image makes it possible to experience the room's mood as a visual reality for readers.

The depth of the Appalachian hollows, seen by the farmer from his porch with his well-worn furniture, utensils and plants. The camera manages depth of field with a small aperture.

The camera performs well with this adjustment, bringing into focus both background and foreground, like squinting your eye.

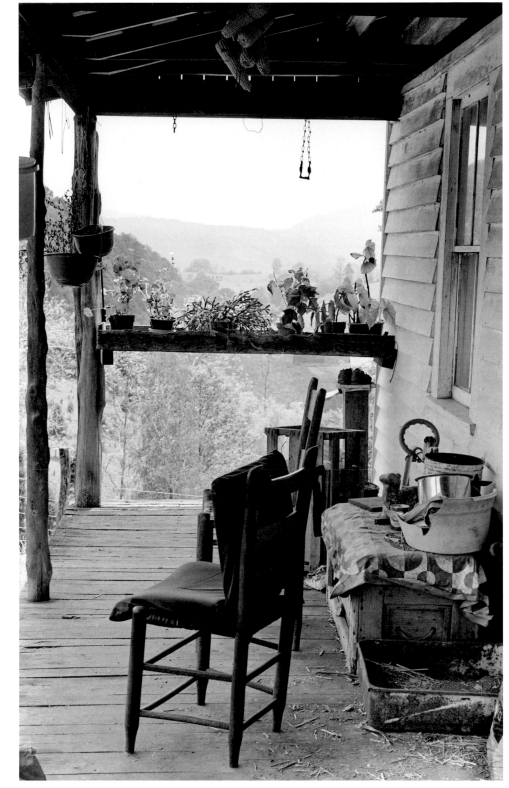

Lebanon, Virginia 1989

5

A photographer needs...
a relationship between
the eye and the heart.

HENRI CARTIER-BRESSON

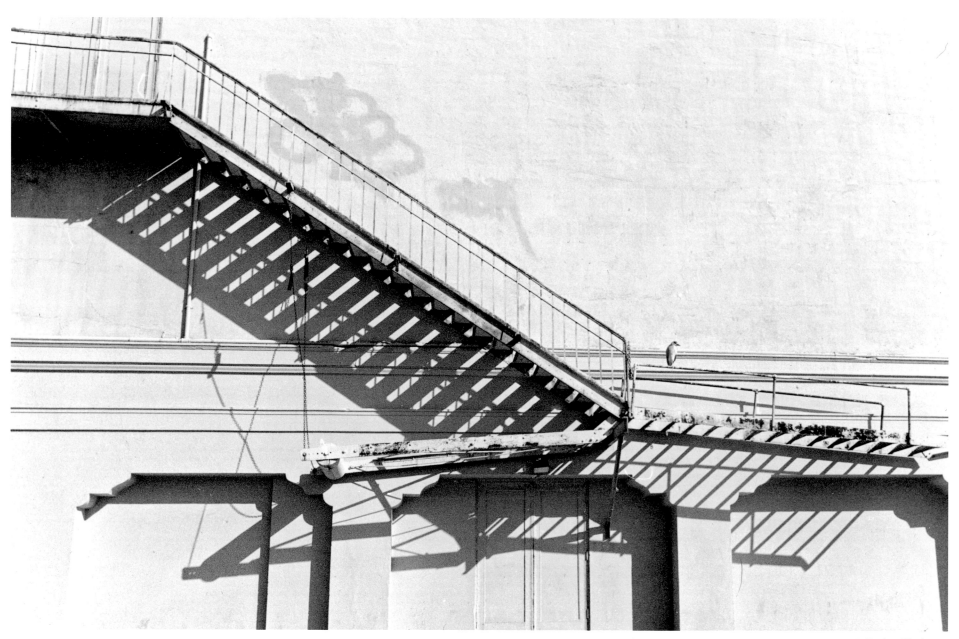

Oakland, California 2010

It is the heron that touches the heart, sitting there
amongst the cold metal and shadows.

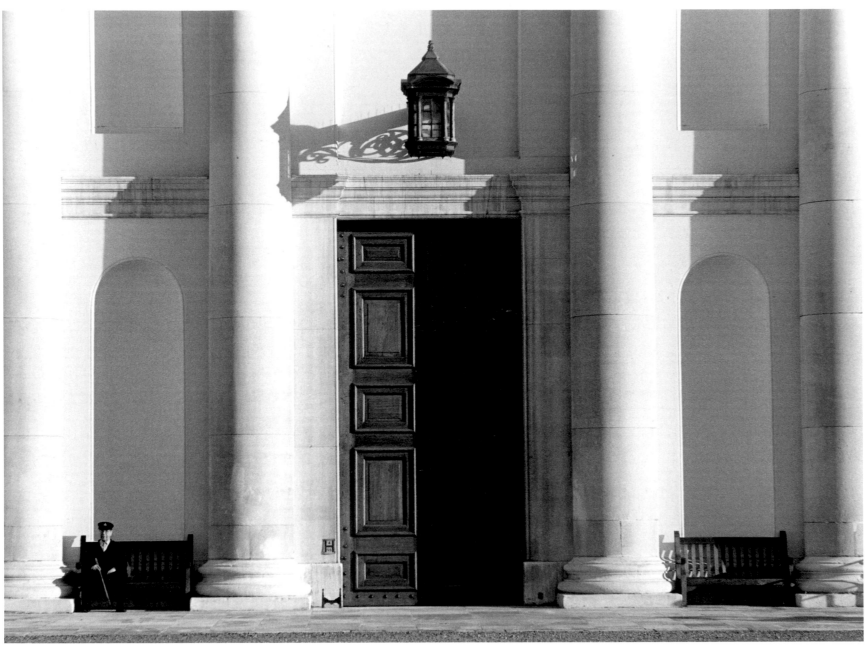

London, England 1995

Life can look like a theatre piece when nothing is happening.

The subject is "fixed" and the print will be fixed with chemicals that keep the silver image from washing away. This was the second most important discovery in photography after capturing the image. The familiar smell of fixer was what one experienced in the photo studio where processing went on.

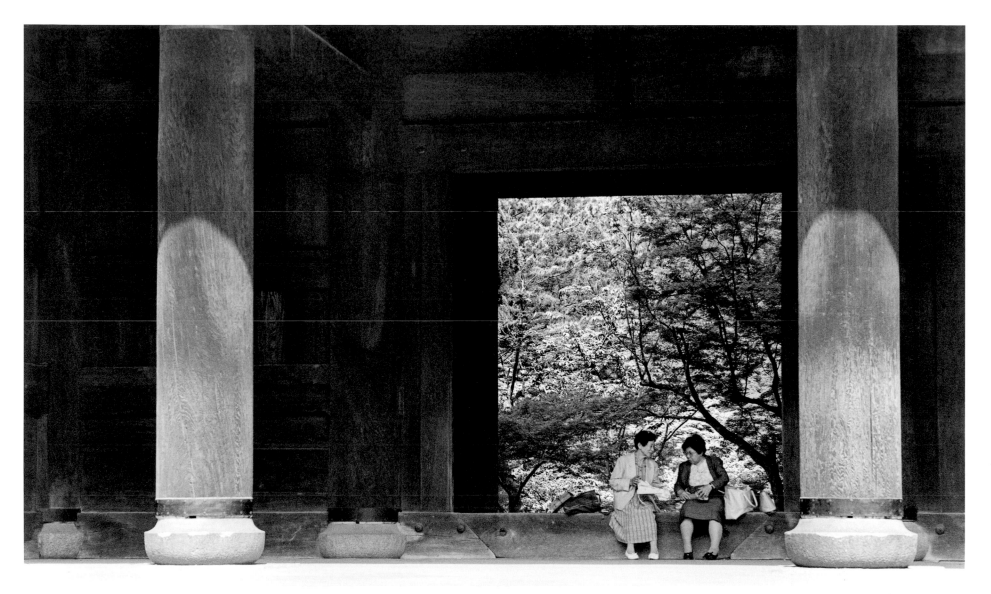

Nanzen-Ji, Kyoto, Japan 1992

Photographers enjoy seeing equivalences.

Dwarfed by the magnificent old wooden columns, her legs reveal a similar power of their own.

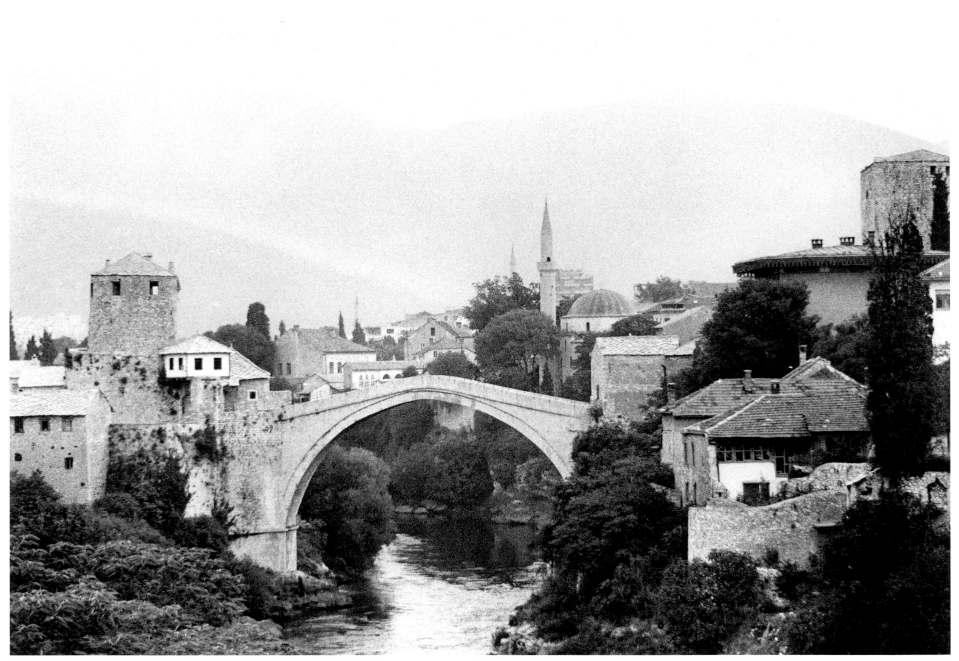

Mostar, Yugoslavia, 1991

Stari Most bridge over the Neretva River in Mostar was built in the 16th century. It was said that the aura of its presence surpassed any function. Built under Ottoman Turks, it was celebrated for its grace. The bridge was destroyed by Croatian forces in 1993 during the Bosnian War, and was rebuilt in 2004.

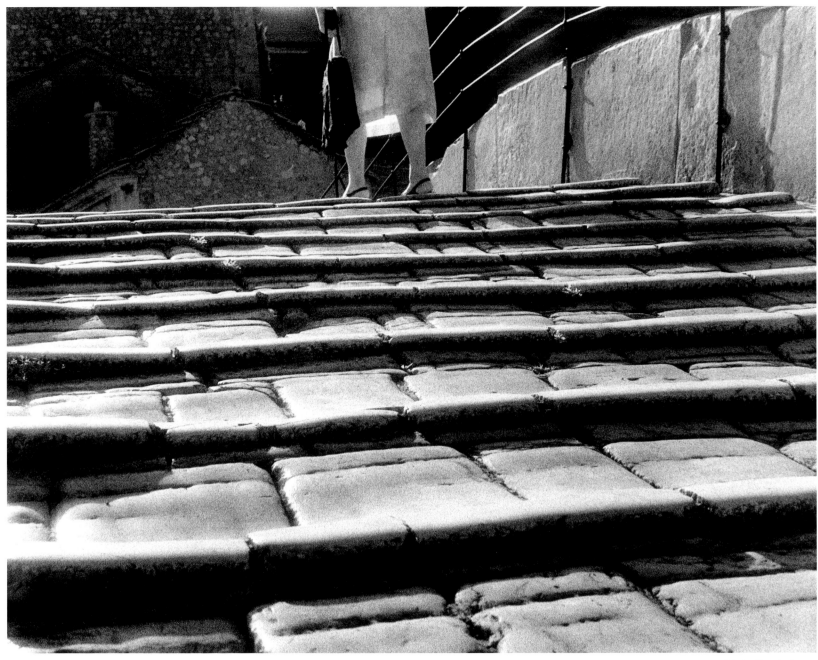

Mostar, Yugoslavia 1991

The stones did not know they would soon be bombed to destruction.

Infrared film was chosen to contribute to the shimmer and glow of the ancient tenelija stones of the Stari Most bridge.

"To put in contrast differences
in form, color etc.....
to heighten the total effect..."

THE OXFORD UNIVERSAL DICTIONARY

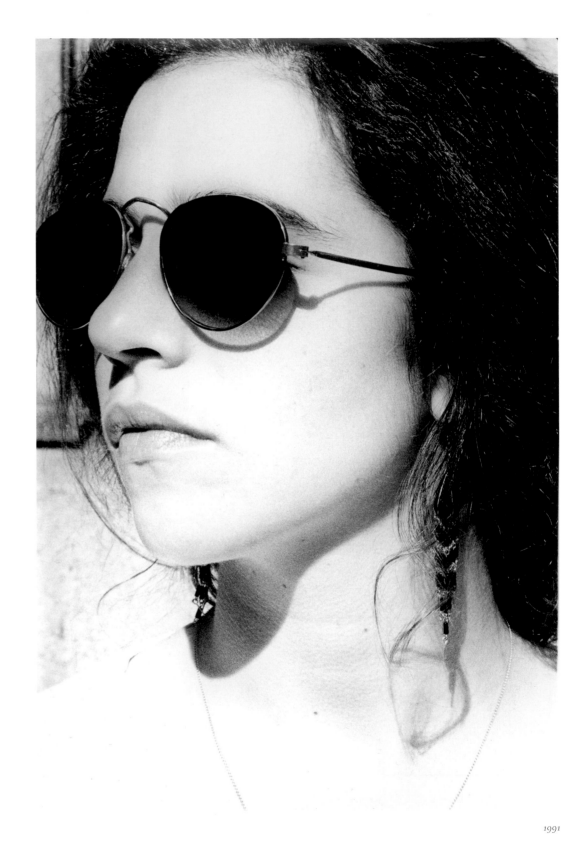

A bright complexion owed to silver halides.

The contrast of deep black and bright white produces an almost graphic effect. The film's emulsion is gelatin, holding silver halide crystals. Strong light captures lots of silver in the film which, when converted to silver metal in the developer turns black on the film, which blocks the light from the enlarger when printed on white paper. Contrast can be controlled digitally so easily!

1991

14

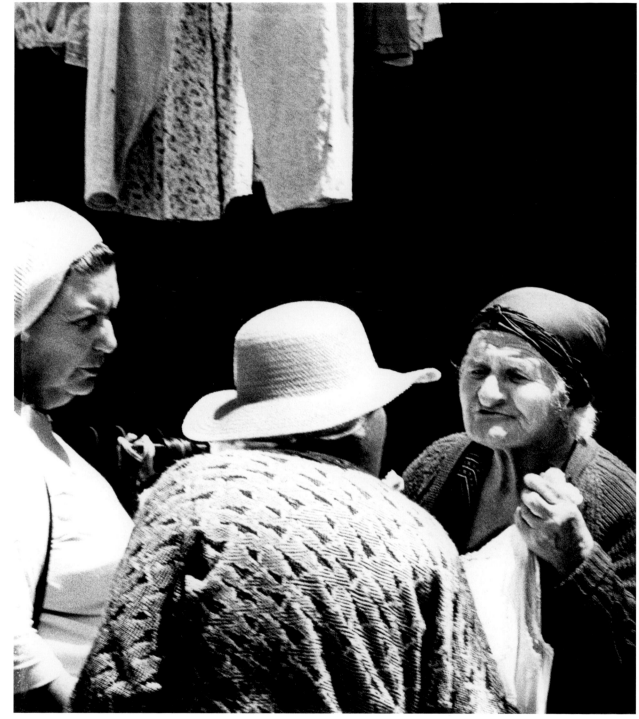

An intense human moment printed with high contrast to emphasize its structure and drama, aided by strong sun. The black space beyond has a force of its own.

Contrast can be increased by using variable contrast silver papers or with the use of filters in the enlarger. Many possibilities for manipulation exist in the dark-room and with the digital image.

Machane Yehuda market, Jerusalem 1989

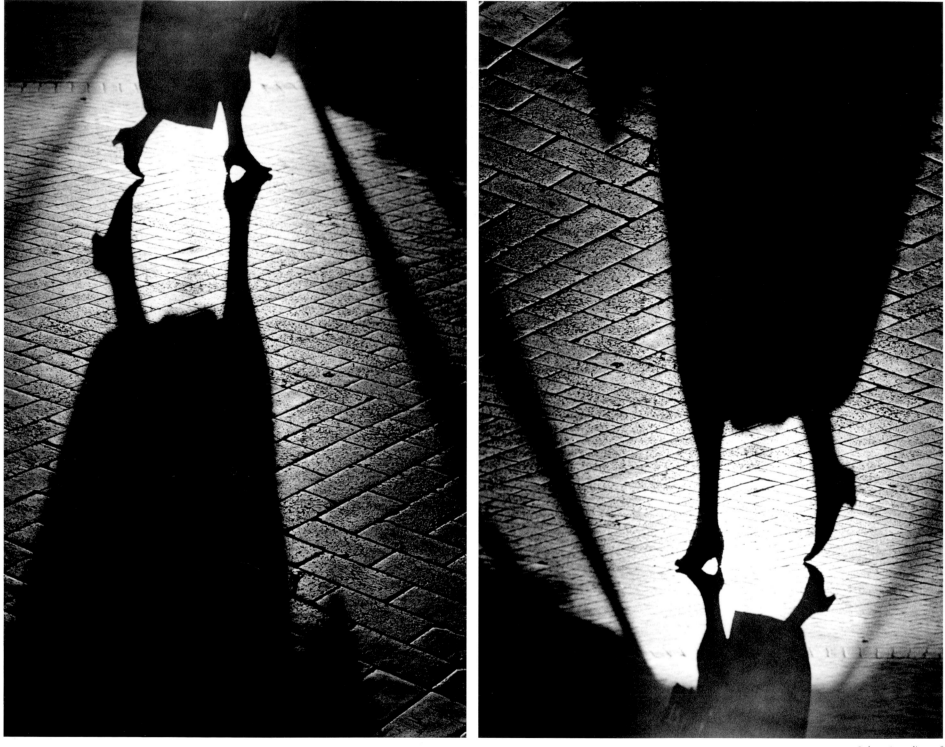

Bringing the shadows to life with a simple inversion of the image!

Sydney, Australia 1996

Conjuring tricks with the printed images. In losing
our normal relation to the known, there is surprise and
delight in viewing a strange orientation.

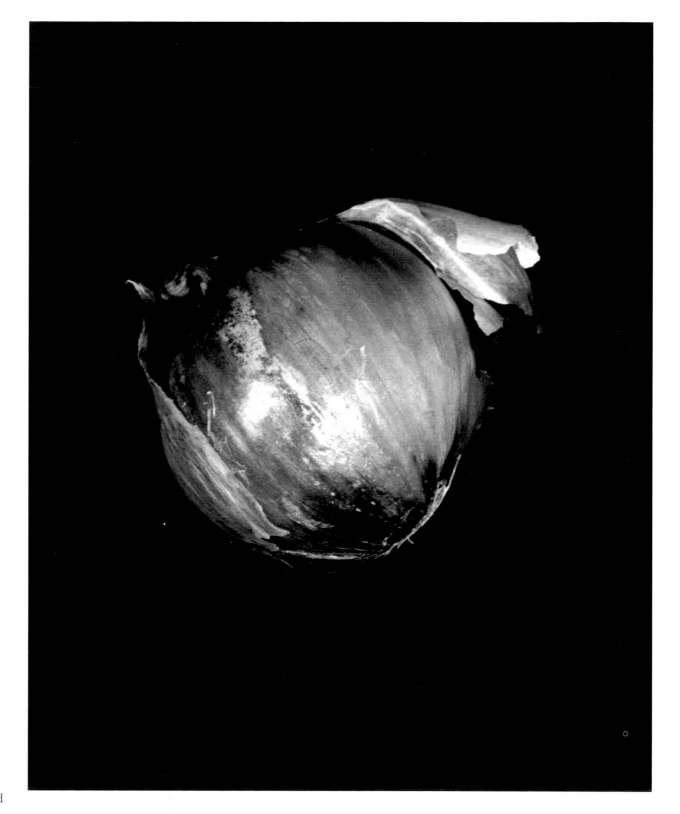

Onion Planet

An onion, with a delicate peel like a wing, becomes an art object when placed on a black cloth, and suspended in time and space, it takes off!

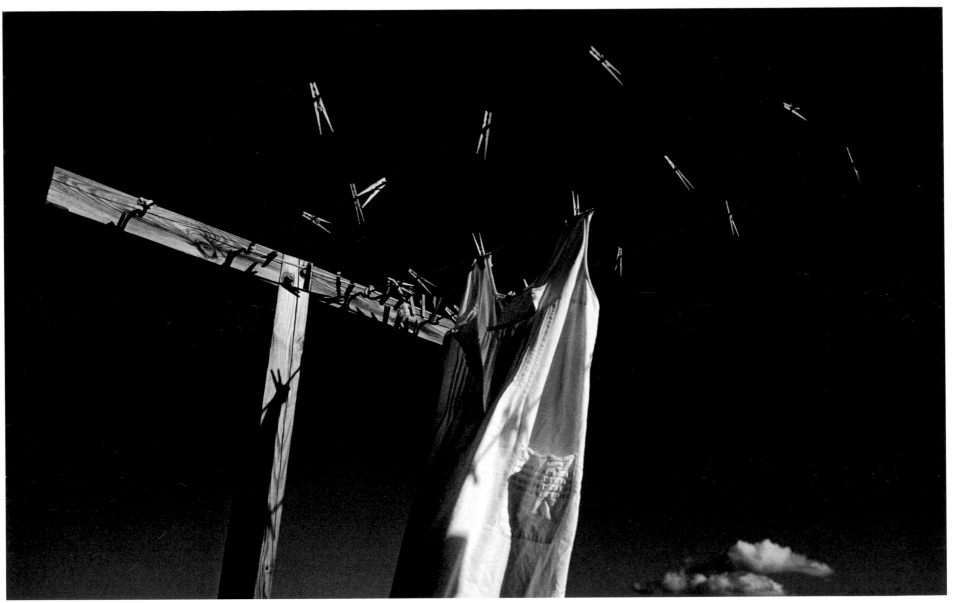

Cape Cod 1998

Looking on a simple scene, but with a red filter and from a different angle.

A red filter on the lens creates a dramatic contrast, darkening a blue sky to bring out the white forms. This filter requires a longer exposure time to compensate for less light coming through the dark red glass.

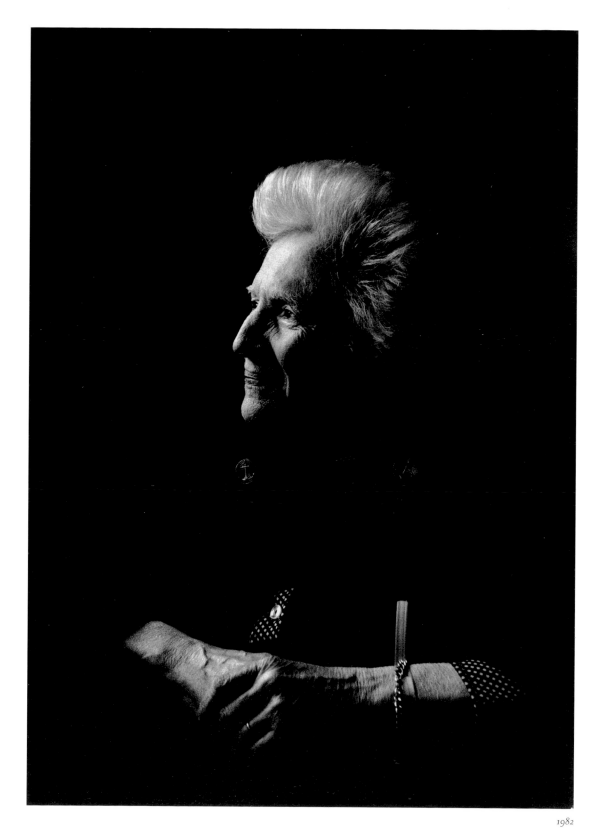

*"Maybe the most important picture taken is the first.
The biggest influence on a photographer is his own pictures."*
AARON SISKIND

The sensitive use of available light brings beauty out of
the darkness.

1982

Experimenting with

INFRARED *film*

often produces

dreamlike,
mysterious and
unexpected results.

Rosh Hanikra, Israel 1991

"The only way to conquer death is through photography."
JEAN COCTEAU

In an extravagance of light Infrared film will give a florescent glow to objects and can even penetrate a few millimeters of skin to give an other worldly aura. It can similarly penetrate the surface of a painting to reveal what may lie beneath.

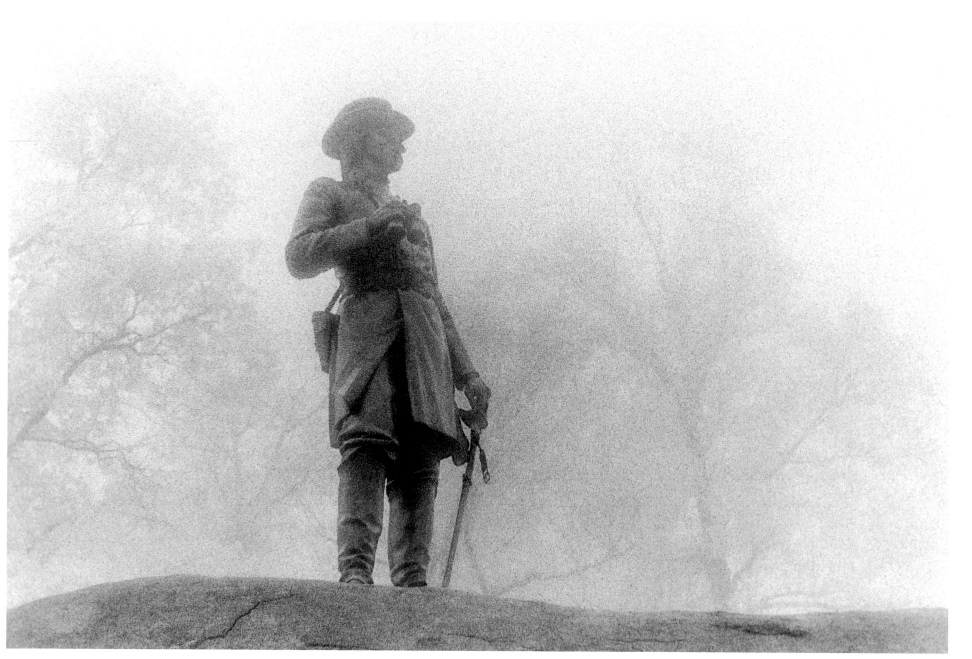

Little Round Top, Gettysburg, Pennsylvania 1989

Rain and fog, and those trees could not be seen by the photographer, but infrared film penetrates the fog and reveals them later in the print!

Infrared's longer wave lengths record what was unseen by the naked eye, as the radiation is not scattered by water particles. Seeing the trees in the print is a surprise for the photographer!

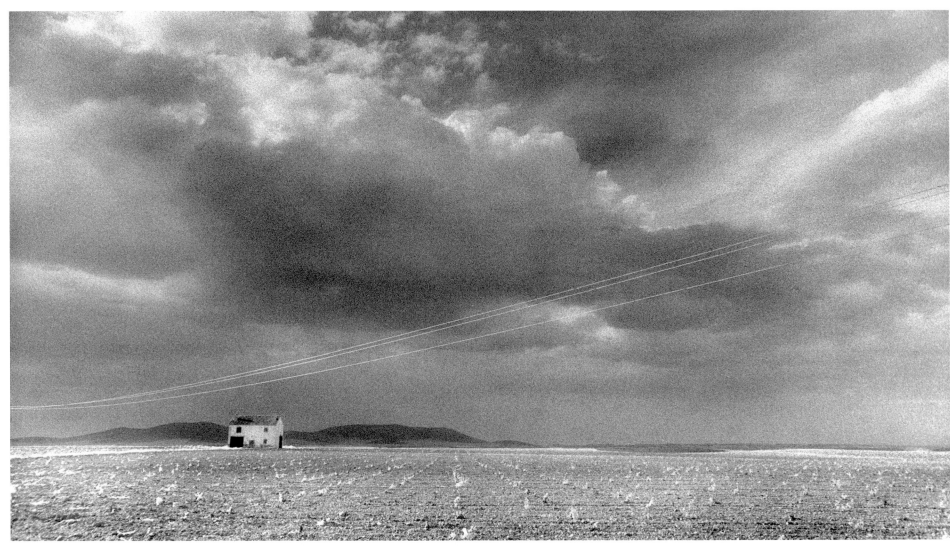

Road to Rio Azuer, Spain 1991

Wires that one might photoshop out of existence are intentionally brought out with infrared film.

As well as bringing a glow to the lone house, the infrared film may be recording the thermal energy of the high tension wires.

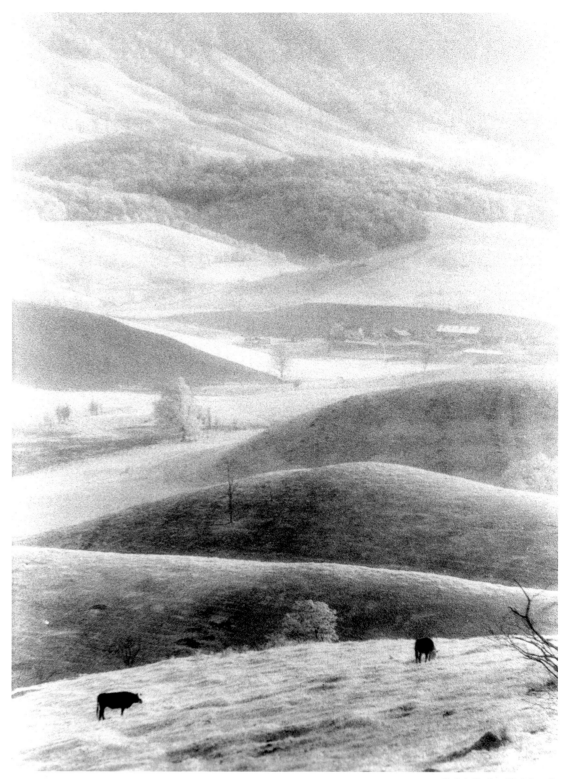

A dreamy atmosphere created by infrared film through its soft effect and graininess.

The green grasses of the Appalachian hills may appear white as a result of the effects of infrared film which reflects the infrared light waves given off by vegetation, so that even more silver deposits are lain down on this film. When a print is made through the negative, those areas appear lighter in the print.

Burke's Garden, Virginia 1989

25

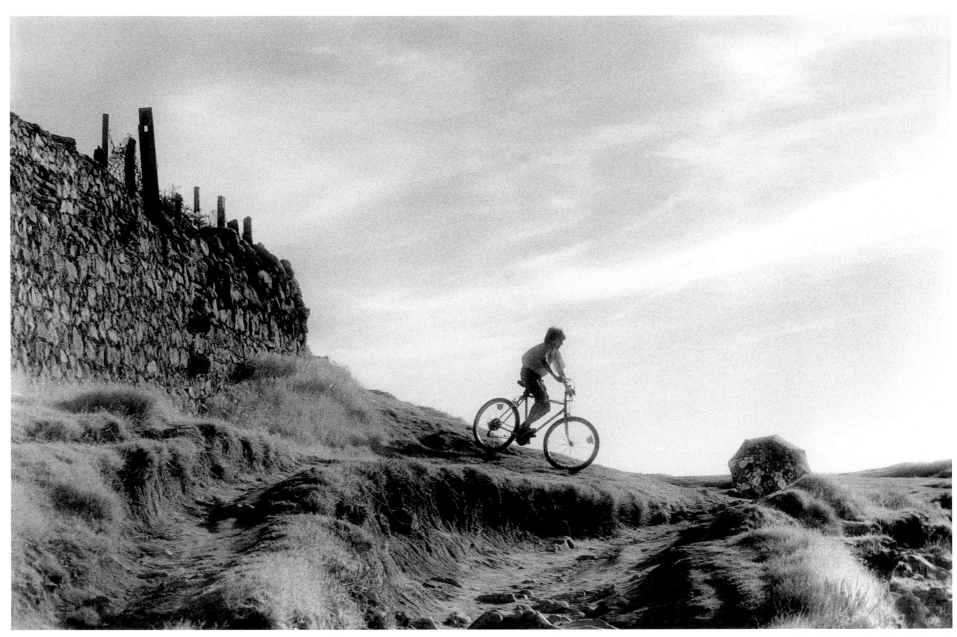

Playa de Llencres, Cordilleras, Spain 1990

As the boy goes back and forth, the photographer using infrared film has time to adjust the focusing point, as this film requires.

Lenses do not focus infrared radiation in the same place as visible light since infrared radiation is longer. The lens must be moved slightly farther from the film or focal plane. Most cameras have an infrared focusing mark. There are now digital infrared cameras.

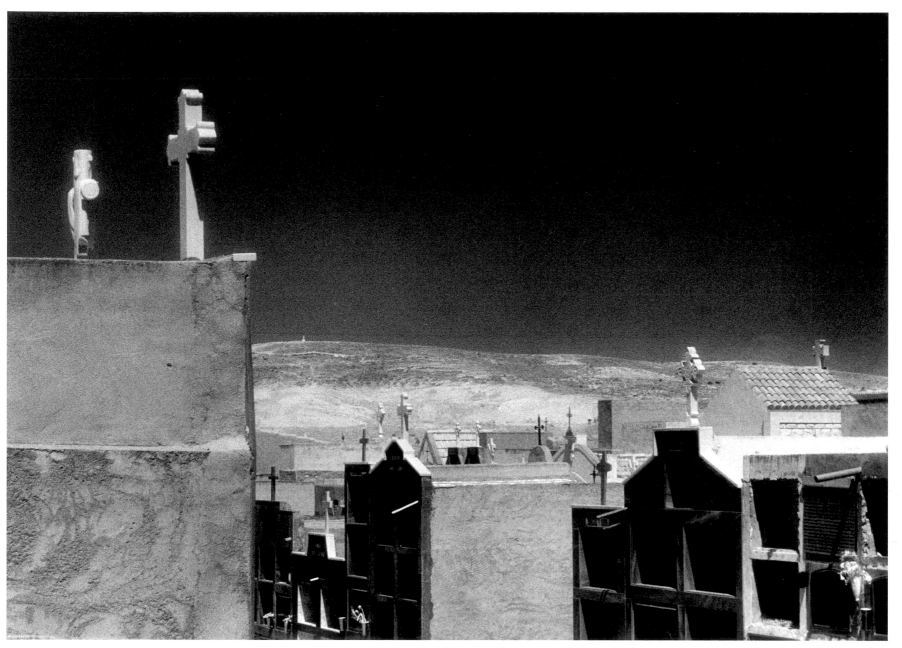

Maigmo, Alicante, Spain 1991

Seeing with the intention of altering the reality, imagining the effect with infrared film.

Called a silent city, this grim necropolis is characterized by narrow streets between the walled graves and the coffins thrust into cells. Infrared film, used with a dark red filter, blocks out the sky's blue rays, and creates a dark sky accentuating the harsh reality of the place.

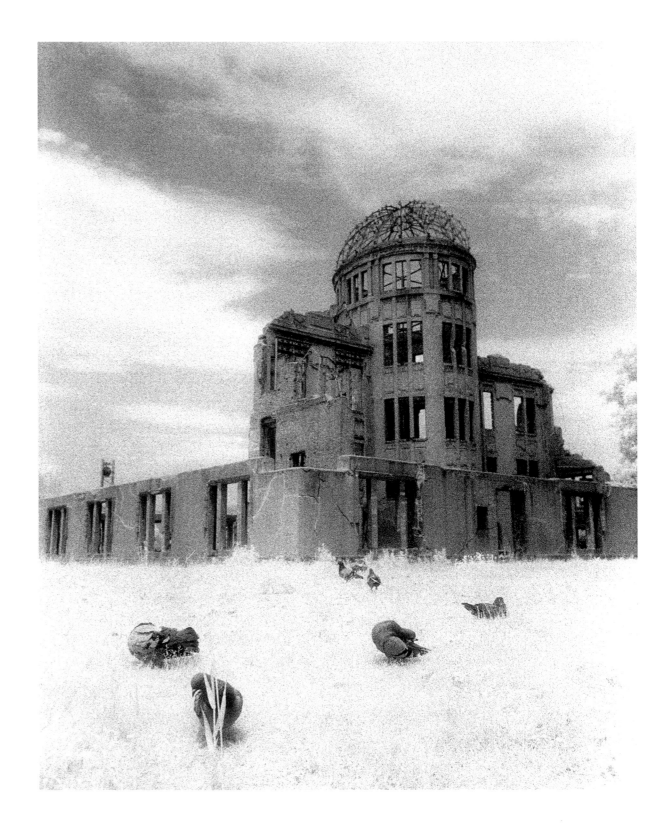

Film sensitive to infrared radiation is used, keeping in mind the "other" radiation here, near Ground Zero, Hiroshima. The building's skeleton is now part of a peace memorial. The doves: a metaphor for peace?

Infrared film presents another problem: exposure is never certain as camera meters measure only visible light, so test exposures need to be made, called "bracketing". With longer and shorter exposures, one of them should be correct.

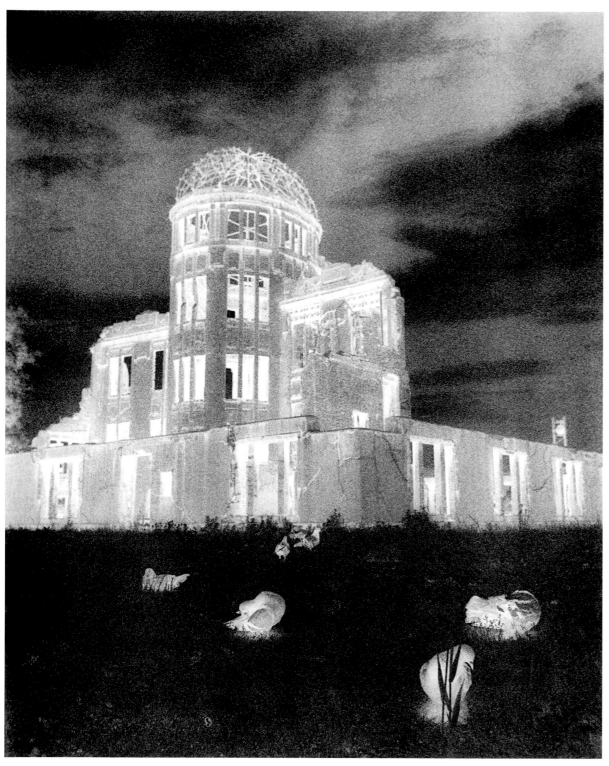

Hiroshima, Japan 1982

The Negative print gives the image an even more radioactive look.

The enlarger's light goes through the small Negative of the image onto a large piece of film, making an enlarged **film Positive**. This is placed directly onto another piece of film and exposed, creating the enlarged **film Negative** ready to contact print directly onto silver paper. The **Positive film** creates the **Negative** print. It is **Positively Negative!**

Photographs can provoke.
They demand response and,
like children, require it more
of the heart than of the mind.

JANE CORKIN

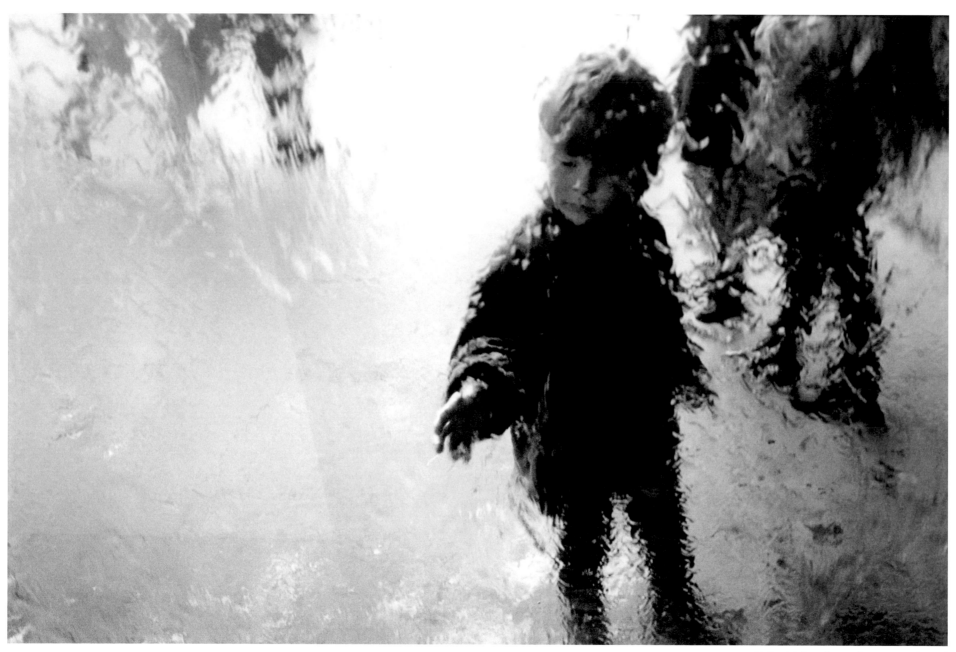

National Gallery of Art, Melbourne, Australia 1996

The child, like the camera, tries to capture what he sees.

Water runs between the double panes of glass separating the child and the photographer who spies on him in full view.

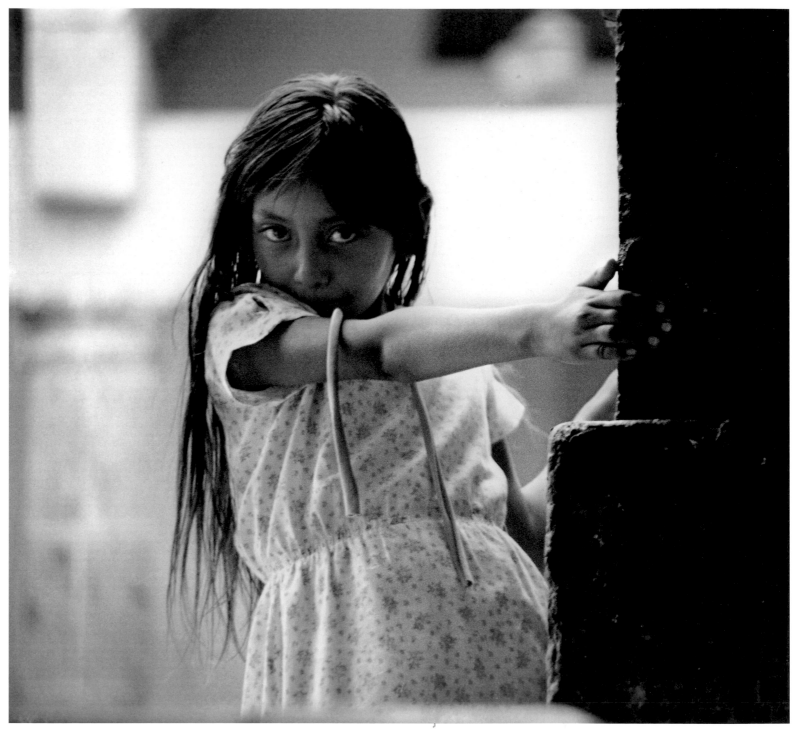

San Miguel de Allende, Mexico 1988

"The eyes are organs of asking."
DAVID LEVI STRAUSS

Shy innocence doesn't understand its attraction. The photographer struggles, at that moment, to let her know that her image is desired and that she is safe.

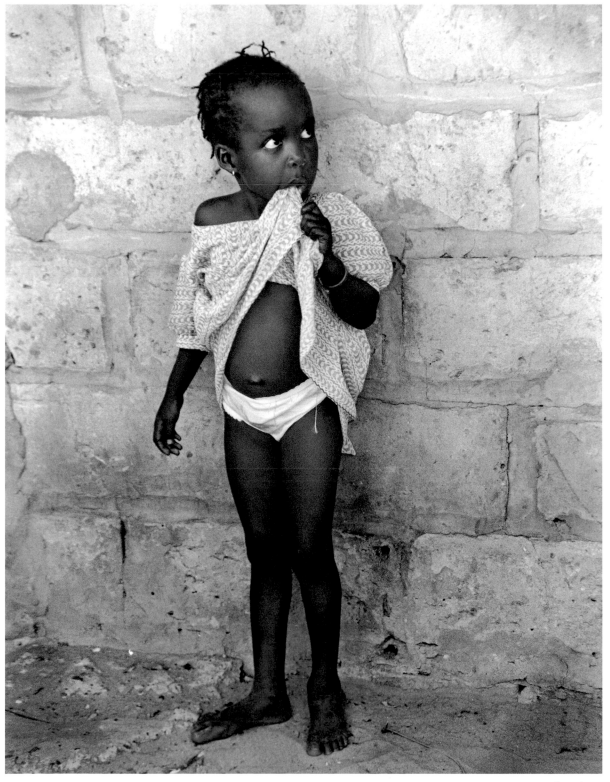

Senegal 2005

"Art is theft."
JANET MALCOLM

With finger on the shutter release, the photographer seizes the image and gives it to the world.

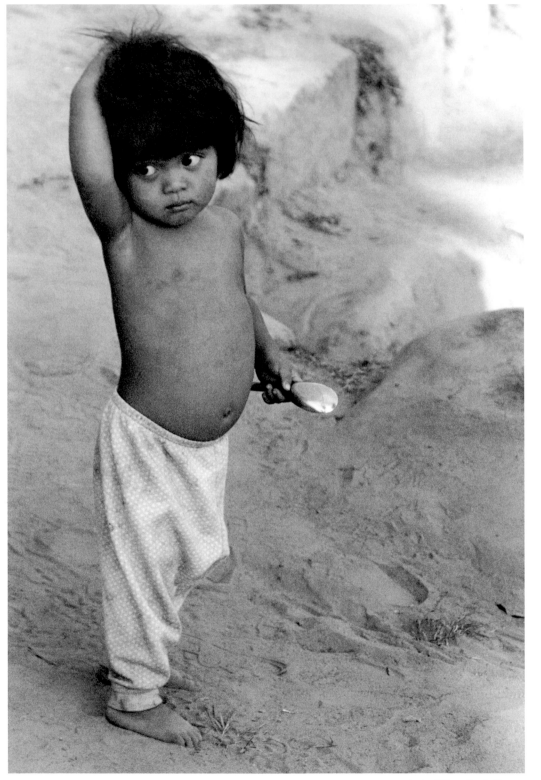

Angkor Village, Cambodia 2005

"The aesthetic is in the reality itself."
HELEN LEVITT

The photographer can use the camera as does the musician to express the soul through her instrument.

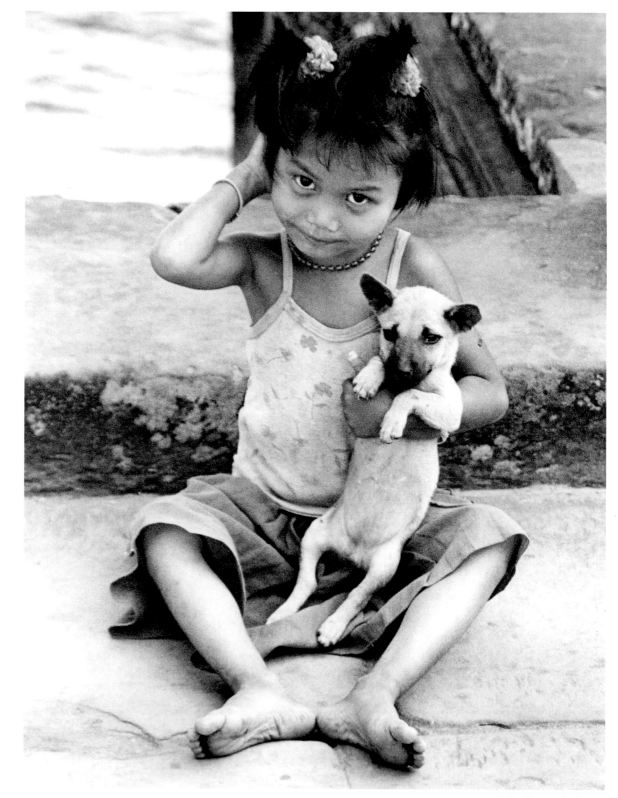

"You cannot claim to have really seen something until you have photographed it."
EMILE ZOLA

Aside the monumental temples of Angkor Wat, the photographer chooses to make an image of the child and the sweet jumble of limbs, rather than of the magnificent stone temples nearby, built by the Khmer kings between 810 and 1220.

Angkor Wat, Cambodia 2005

35

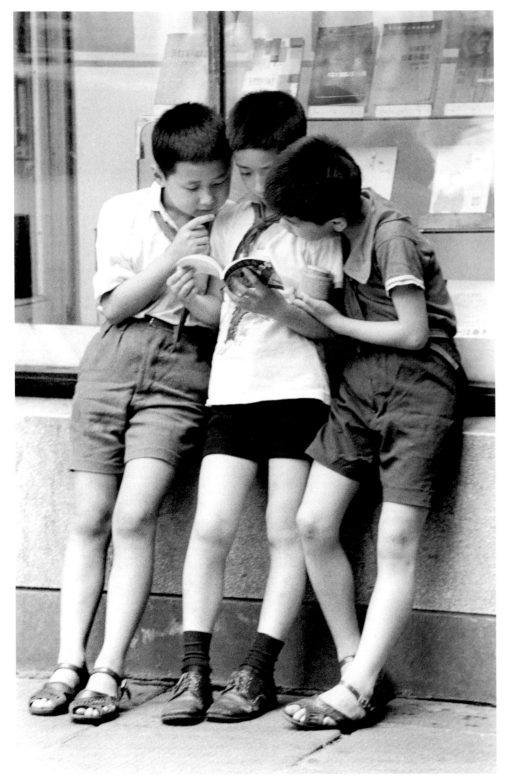

Shanghai, China 1982

"You don't have to imagine things; reality gives you all you need."
ANDRÉ KERTÉSZ

The gift of photography: recording moments never to be repeated. Luck makes up for opportunities missed.

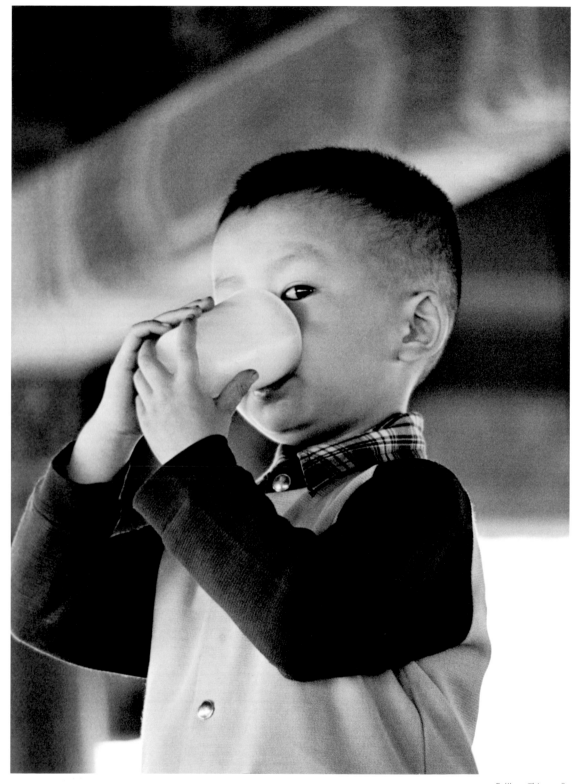

The all-seeing eyes: the boy's, the photographer's, the camera's.
Who is observing whom?

Beijing, China 1982

37

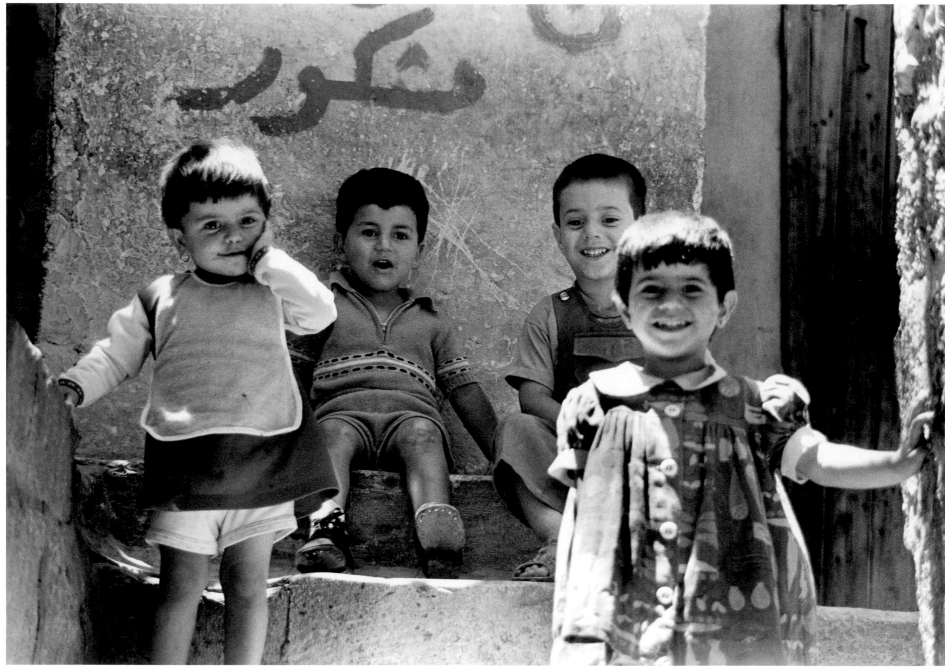

Jerusalem Old City 1989

A collaboration confers importance to all involved and gives the photographer a palpable energy.

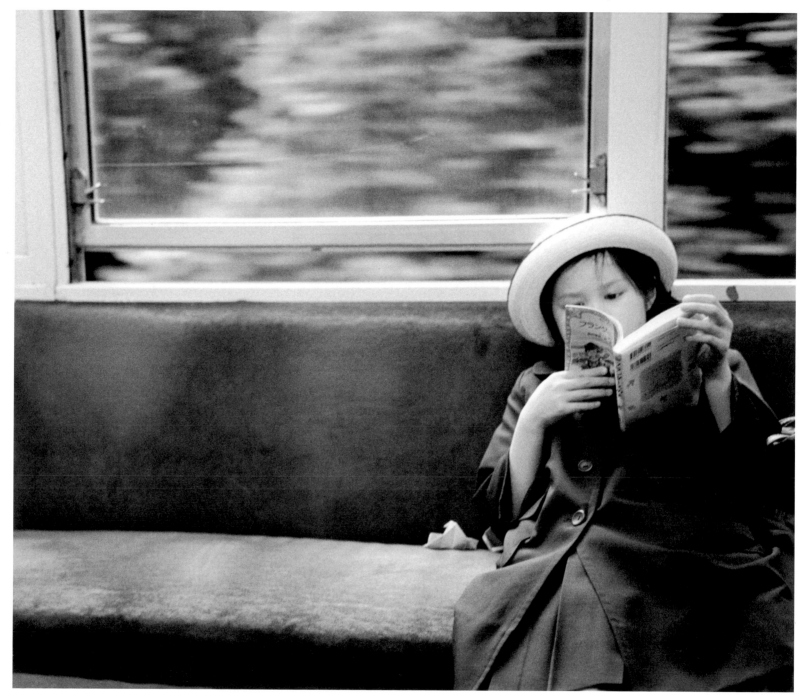

The girl is still and sharp, but with a shutter that is open long enough, the train going by outside is intentionally recorded as a blur.

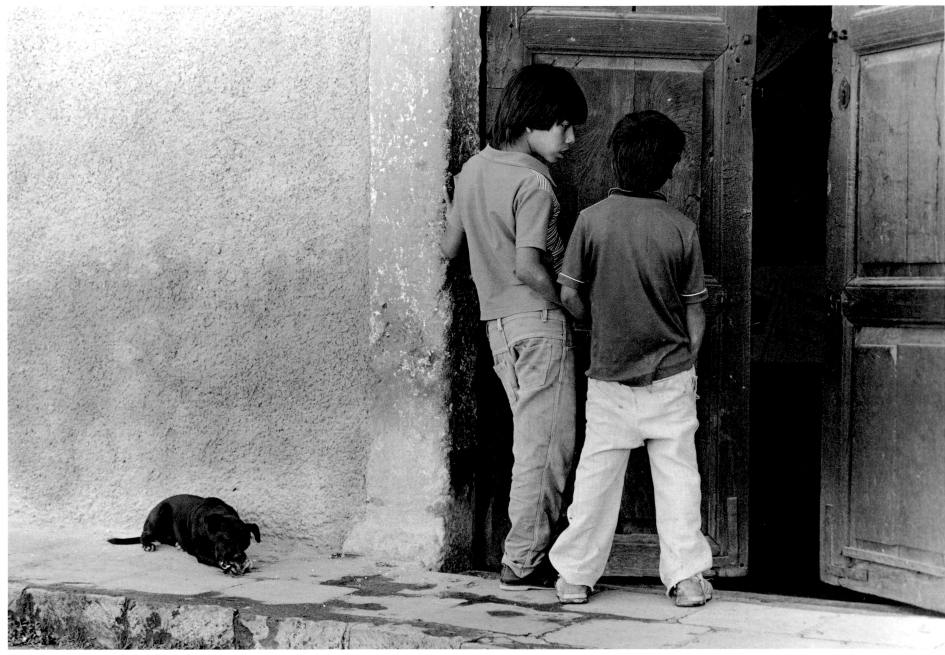

San Miguel de Allende, Mexico 1988

What went on after the photograph was made?

To seize the image as the dog chews, the boys confer,
and the photographer steals away, not knowing how the
scene unfolds.

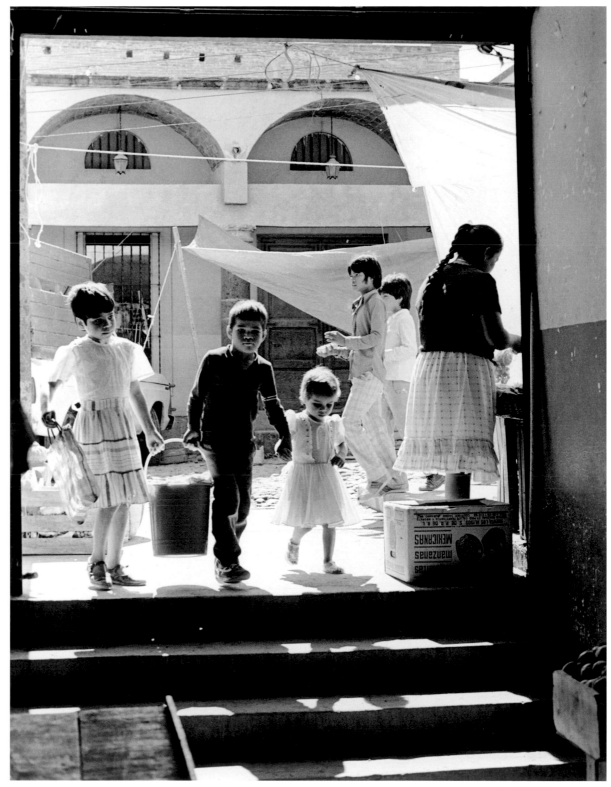

Quickly, before they take one step more and leave the light!

Back lighting of the morning sun isolates and clarifies the little family. Later one sees in the print what was hardly noticed in the rest of the passing scene.

San Miguel de Allende, Mexico 1988

41

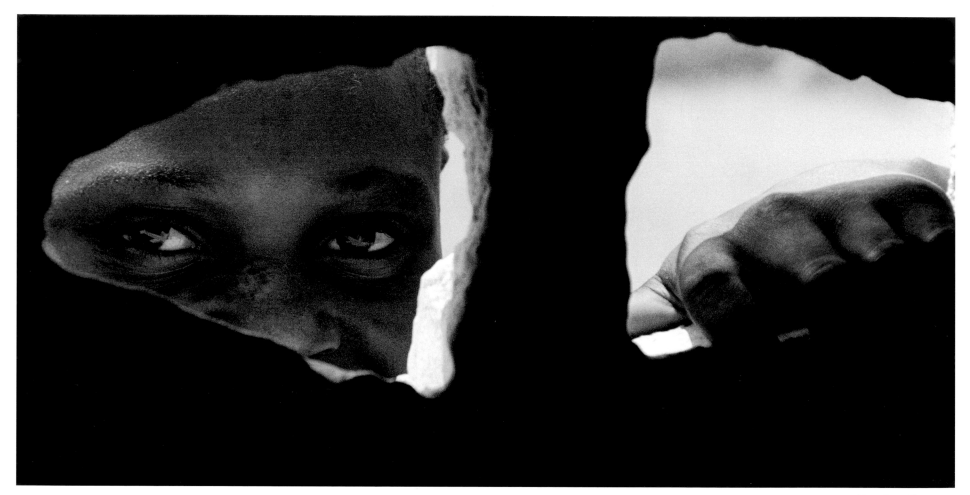

Pram Pram, Ghana 2009

First spied through a peephole, then captured through the camera's peephole in 1/60 second.

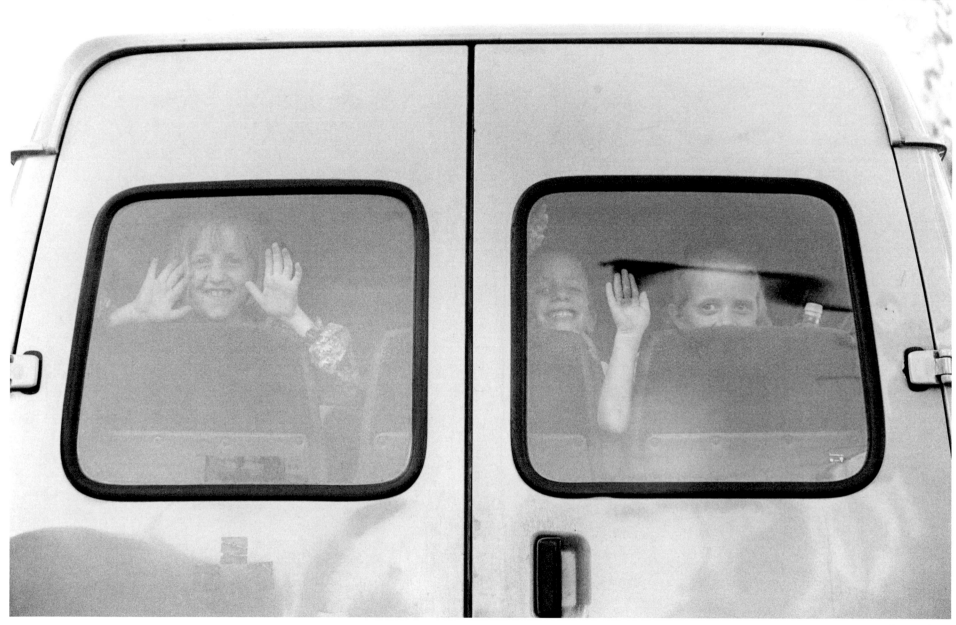

Jerusalem, Israel 1995

Quickly! Take a chance, before the stop light changes.

From inside the photographer's dusty windshield and through the fogged windshield of the bus one quickly grabs the camera before everything changes and the kids are gone. "For photographers what is gone is gone forever."
HENRI CARTIER-BRESSON

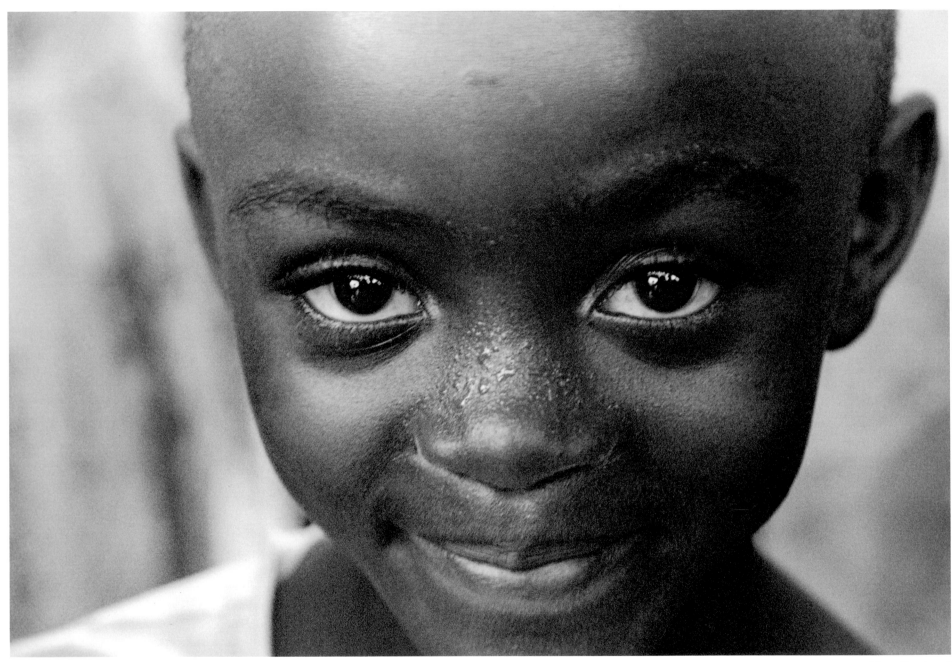

Kiboga, Uganda 2008

A small camera,
a small girl with a great strength in that face.

A "close-up" presents an image that can later be explored
in detail in the print.

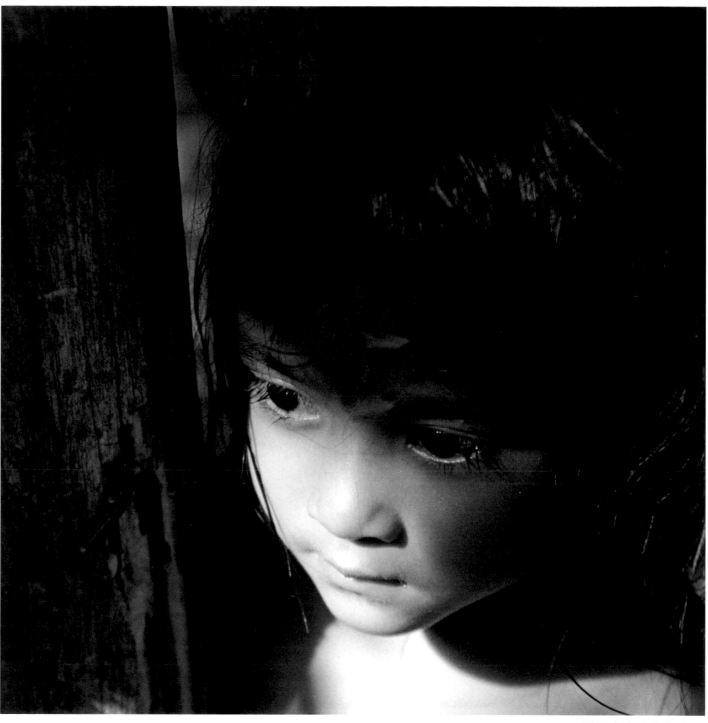

Koh Mook Island, Thailand 2005

Remembering the moment of discovering this face, in a place struggling to recover from a disaster.

A child survivor of the tsunami of 2005 that hit the Muslim fisher folk community in Thailand.

45

The image is made

—taken—

then indeed taken away,

and the country
left behind.

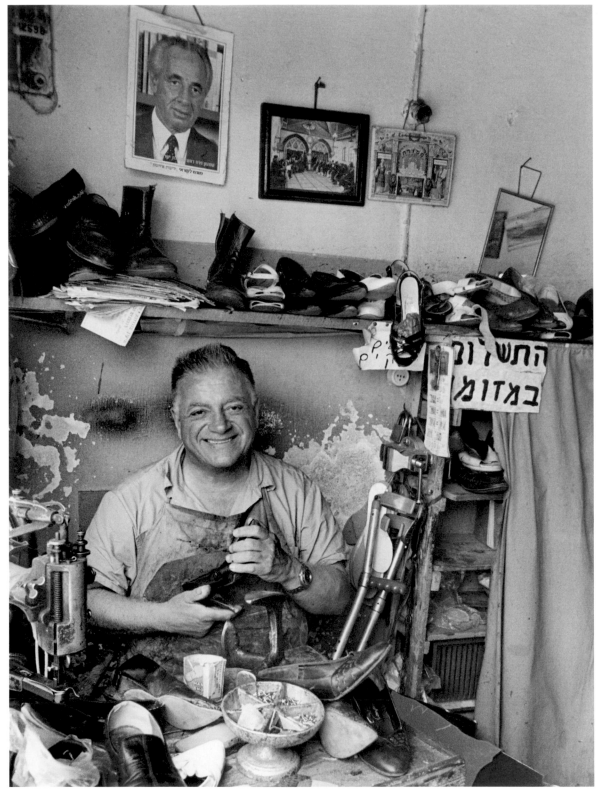

Mahane Yehuda, Jerusalem, Israel 1987

So much of this Jerusalem shoemaker's life and work is caught in 1/60 of a second.

The print allows details of the glorious clutter to be contemplated later at leisure in the print.

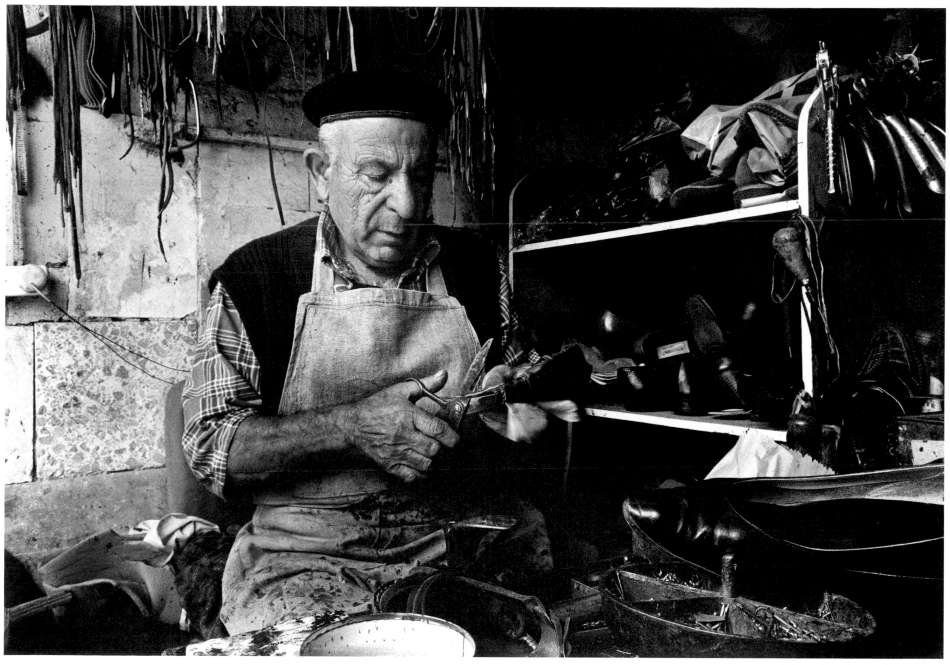

Shicun Habucharim, Jerusalem, Israel 1991

The gentle light gives beauty and dignity to Meir Rabiyov, a shoemaker. The photographer revels in the quality of natural light, taking advantage of its gifts that can create mood and illuminate character.

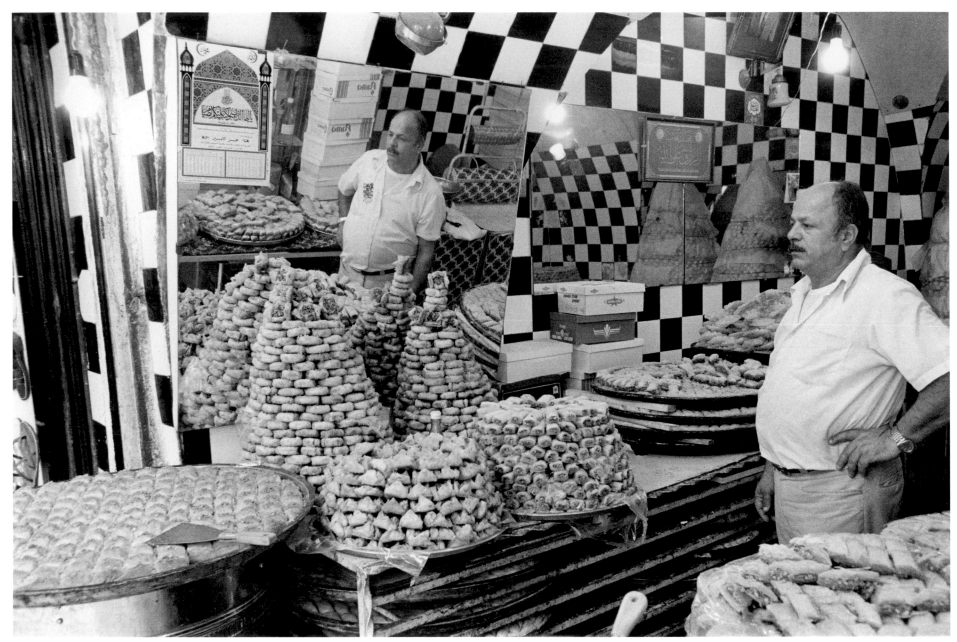

Jerusalem, Old City 1982

The image goes cubist: the eye wanders about.
Multiple viewpoints appear. Where is the foreground?
The background?

The mirror adds complexity to the confusing sight of this
baklava shop in Jerusalem's Old City. We're uncertain of what
we are seeing but know it is something we must have.

A composition of decomposition. These intriguing deposits are left for the camera to acquire and explore: Paper and plaster. Which is which and what is what?

One of the ubiquitous posters (pashkivalim) on the plaster walls of the Ultra-Orthodox enclaves in Jerusalem, and this one is on its way to disappearing. Only photography will preserve it at this point.

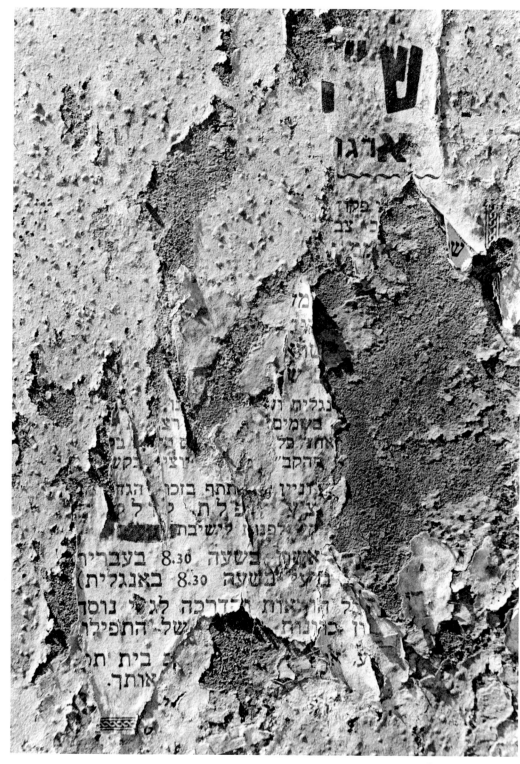

Mea Shearim, Jerusalem 1989

51

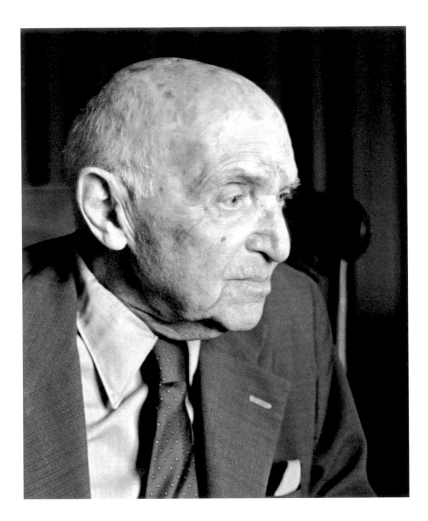

After two clicks, "That's enough now?" He is Nathan Feinberg, age 92. He represented the Zionist Congress at the League of Nations in the 1920s and '30s.

But the photographer wants more... then more. Please carry on with your conversation......

Jerusalem, Israel 1986

The Leica was developed to have thirty six exposures on a roll of film, and it is impossible to choose only one from the contact sheet, since each take exposes a different part of his character. This is the advantage of multiple exposures. It seems the digital has infinite exposures!

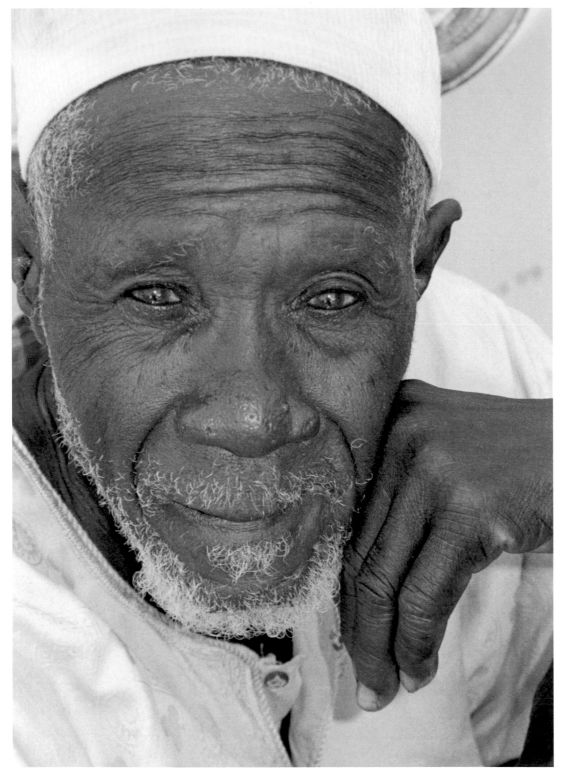

Banjul, Gambia 2005

An unequal encounter: his eyes, clouded with cataracts, and the camera with its sharp, clear vision.

And what does the photographer look like through those clouded eyes?

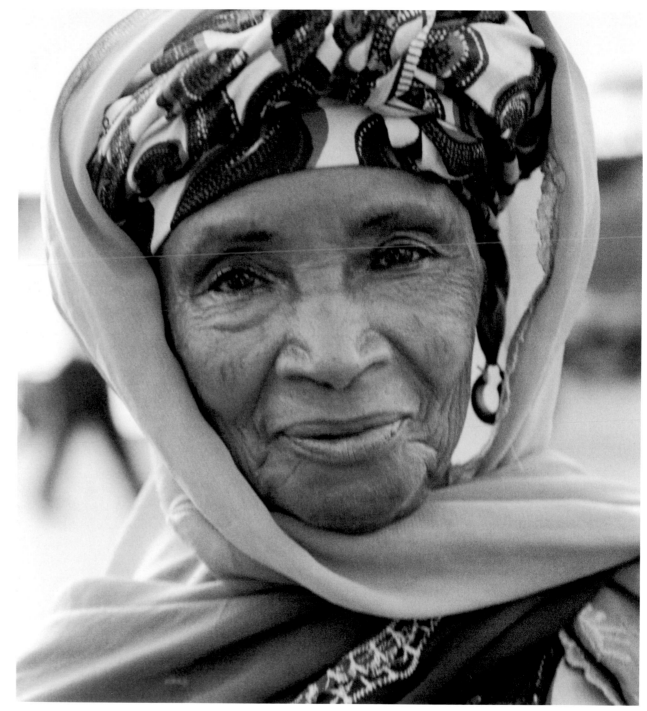

A poetic beauty lies in giving herself to the stranger behind the camera. A gentle approach can yield a graceful response. The image is carried 3,000 miles away by the photographer, who is saved from forgetting.

Banjul, Gambia 2005

55

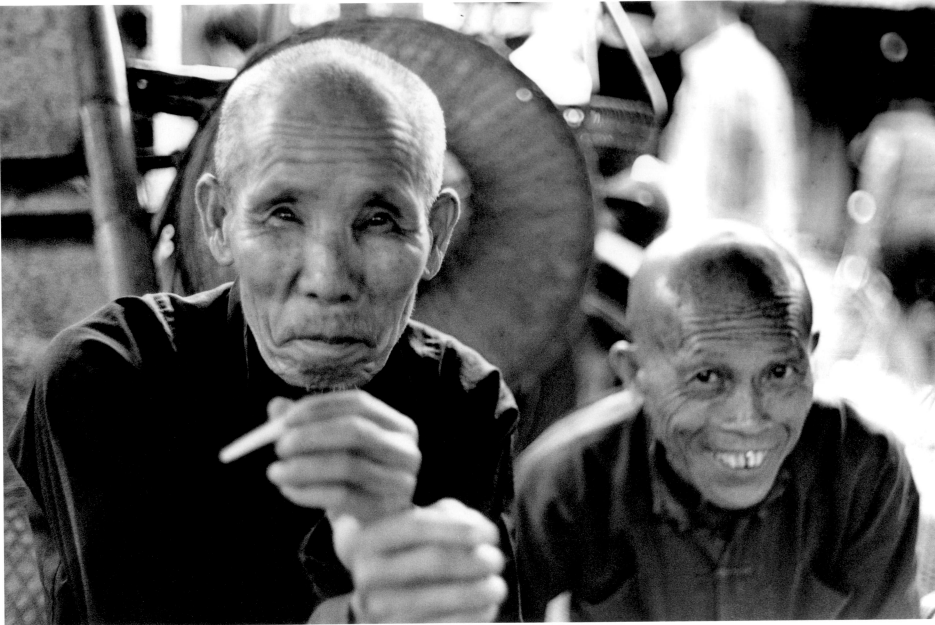

Yangshuo, China 1986

The pair, though unasked, choose to be a part of
the photographer's play. So don't click and "beat it".
Stick around for the fun.

Responding to a pleasant request for permission, he makes a gift of himself to the photographer, although they know nothing about each other. The camera can be a friendly intruder.

The print later reveals the chaos of colliding lines, not paid attention to in the brief moment of encounter.

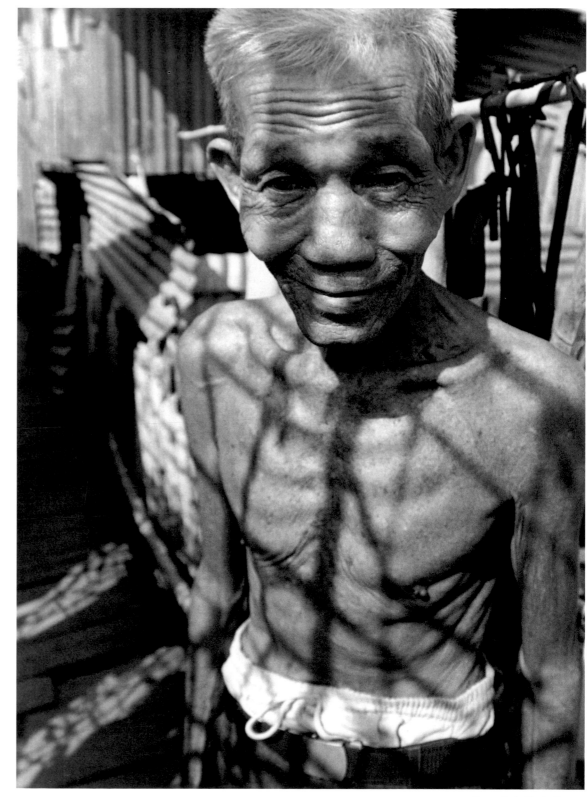

Phnom Penh, Cambodia 2005

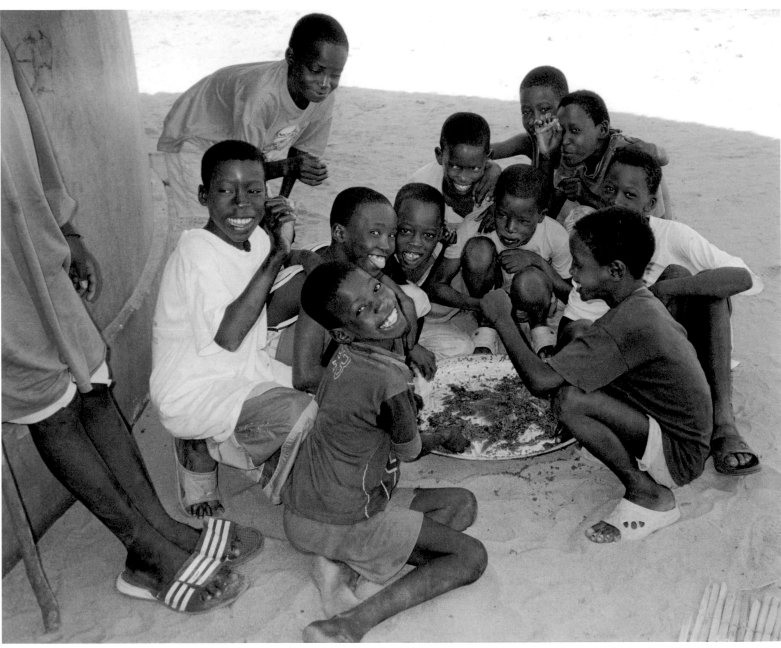

Thies, Senegal 2005

The Talibe boys enjoy the camera's attention.
They get to eat now, after begging in the streets.
A documentary portrait.

They are sent by poor parents to live with the Marabout, a religious teacher, learning from him the Koran by heart, and bringing him the money they earn on the street. Talibe or Taliban means a student of Islam. By a court order of 2010 the Muslim holy men are now to be punished for forcing children to beg on their behalf.

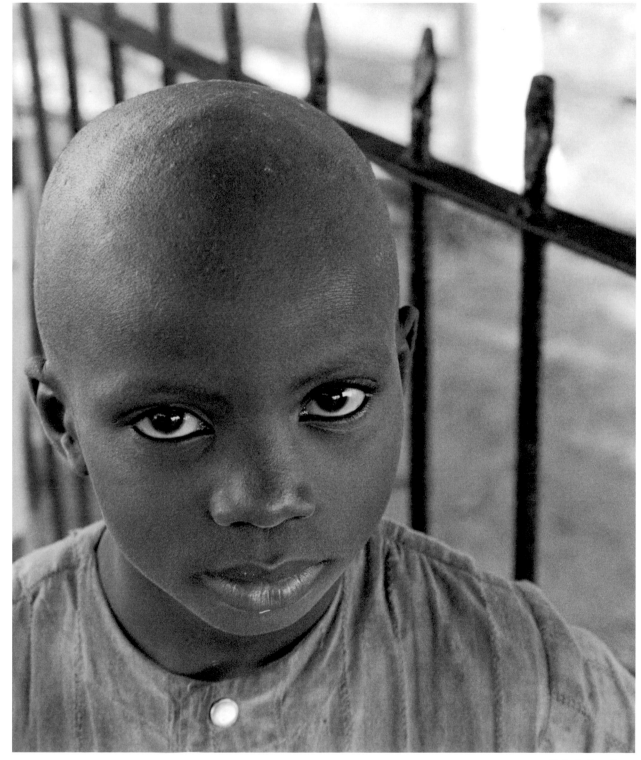

The image is disturbing. The boy is framed in both senses.

The child's beautiful eyes emerge in the developer, affecting one again with his wary glance. A photographer once said that the eyes are seventy-five percent of the face.

St. Louis, Senegal 2005

59

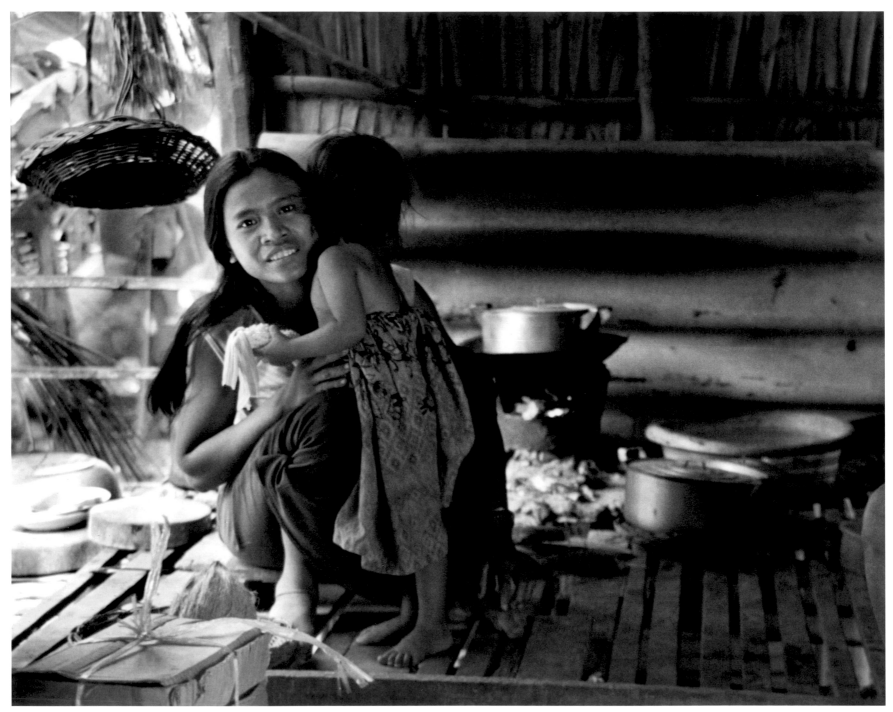

Siem Reap, Cambodia 2005

"The camera is my traveling companion and allows me to stop and explore anything."
SUE SEDGEWICK

Making the image feels invasive, although her kitchen, in her house on stilts, is right there on the road. The camera provides an excuse to approach them, with the responsibility of assuring that they do not feel "used".

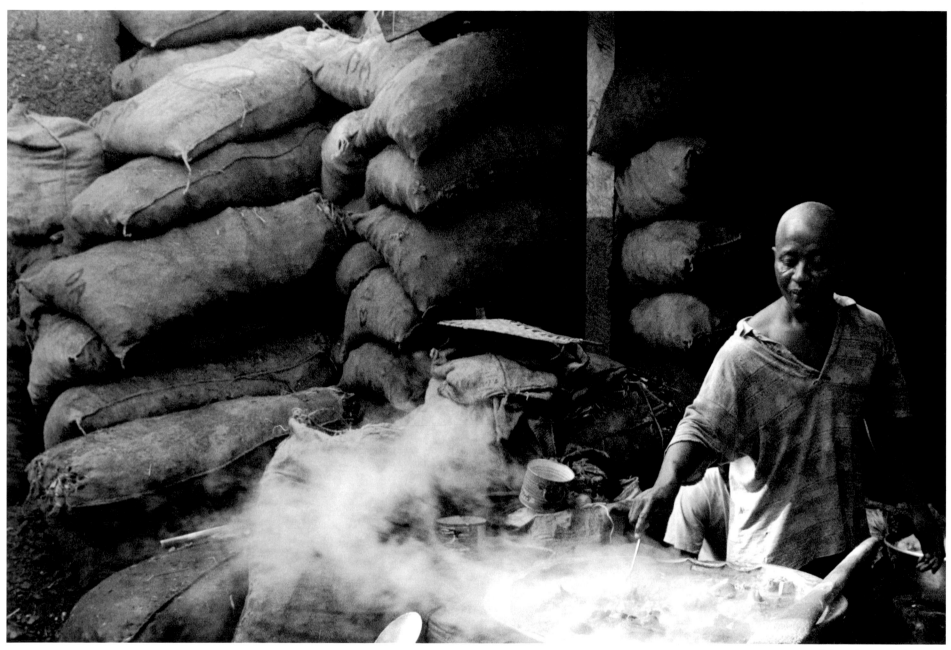

Makola Market, Accra, Ghana 2009

Wandering alone is important for the photographer, paying attention and working instinctively.

The soup will not last past this day, but the image will. Such is the great value of photography. "To preserve life in the act of living."
HENRI CARTIER-BRESSON

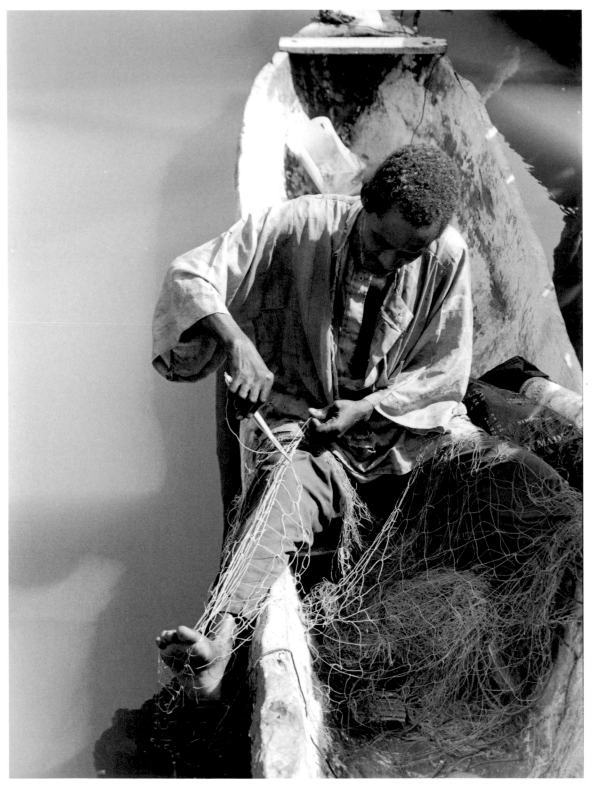

The photographer observes, the eye selects, then commands, and the camera obeys, capturing the fisherman's foot, hands, head, the intensity of his work as well as the net, the boat and the water.

Lamin Lodge, Gambia 2005

62

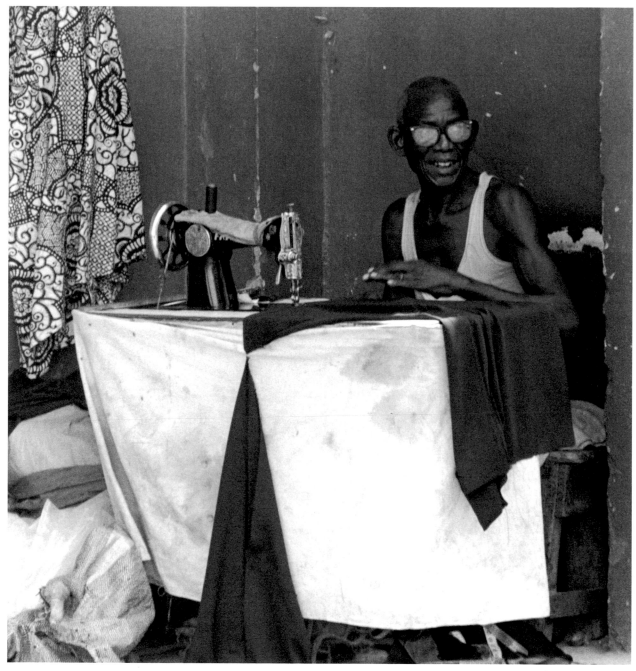

The photographer can be a benign predator, discovering, and portraying with no harm done to anyone.

Many here are Muslim who do not allow themselves to be photographed (the graven image). The photographer has to forego many potentials, and the potential images remain only in the eyes!

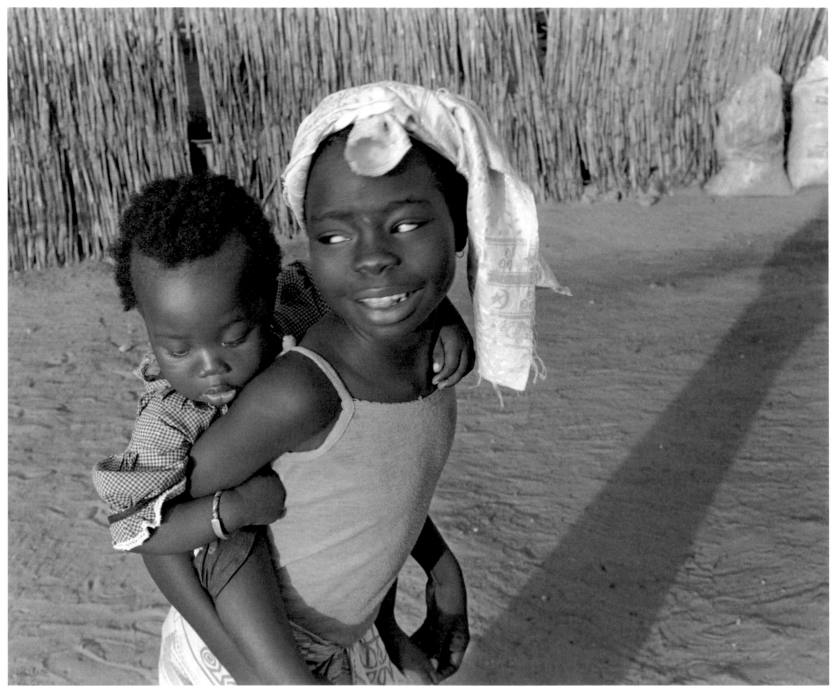

Ndiba Village, Senegal 2005

The magic of this apparatus with an eye that can preserve
these children by their home, on this day, forever!

64

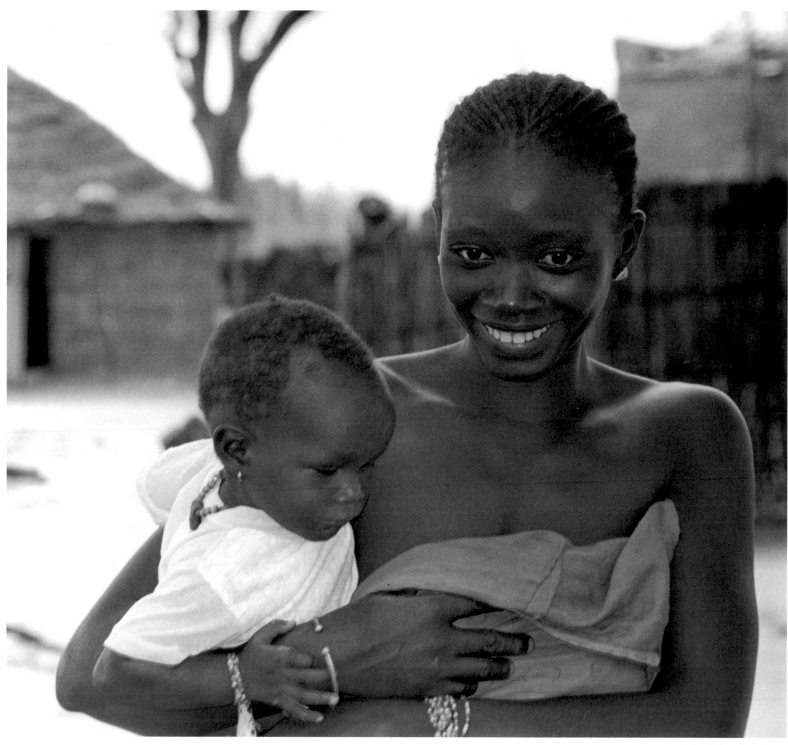

Baliga Village, Senegal 2005

A spontaneous collaboration: her village, her baby, her eyes, her smile. It is the photographer who is caught!

The aperture can be opened a bit to give more light to record this beautiful dark skin.

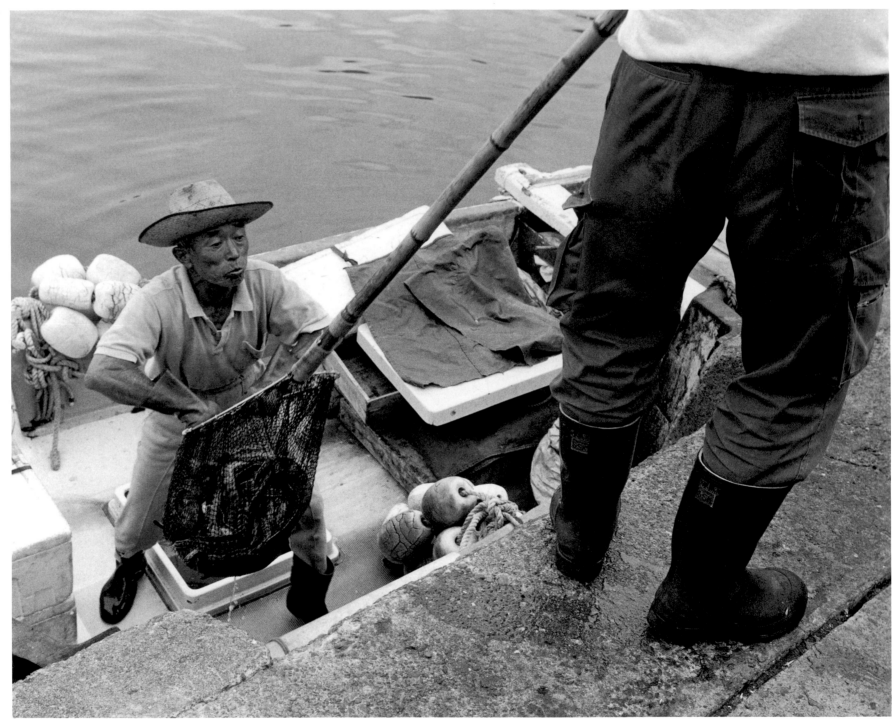

Heda, Japan 1992

Slicing off a piece of the surrounding world to focus in on the important moment of action.

Eliminating distractions (including Mt. Fuji in the near distance) provides more drama to the action, and gives the event its proper expression.

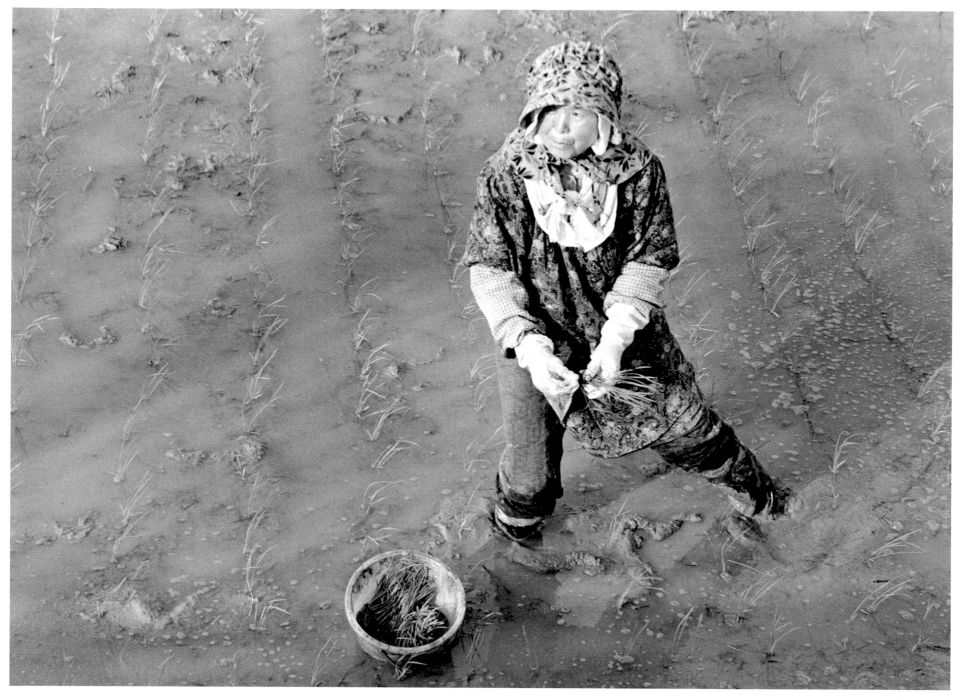

Sanda, Japan 1992

It pays to wait, which takes as long as it takes.

She is seen at a distance while planting rice all along the way. Finally she arrives below the bridge, and the photographer makes a move.

67

Hohoe village, Ghana 2009

"I photograph to see what things look like photographed."
GARY WINOGRAND

The photographer attempts to reproduce what was seen
and felt: the charm and mystery of nature's resemblances.

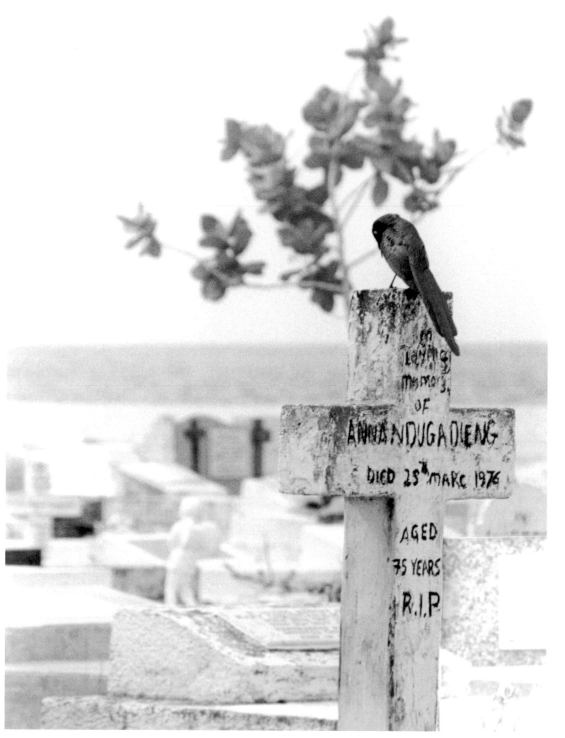

Banjul, Gambia 2005

"The contemplation of things as they are... nobler than a whole host of invention."
DOROTHEA LANGE

On the beach of the River Banjul, a cemetery of freed slaves of the British, and their decendants. Is the bird grieving on the tombstone?

The process of
adding color,
or handpainting parts of
a black-and-white image
begins with

"hmmm......
and what would a bit of color
do here?......or here?"

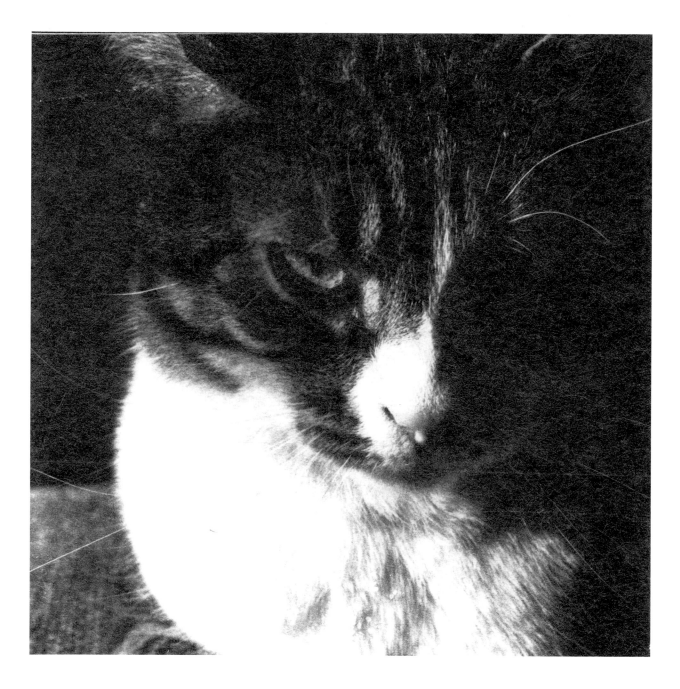

A furry subject on a furry rice paper.

Among the advantages of platinum printing: one can apply the light-sensitive solution to a variety of papers, this one being a "furry" rice paper. Photo oils give Mischa a green eye and a pink nose.

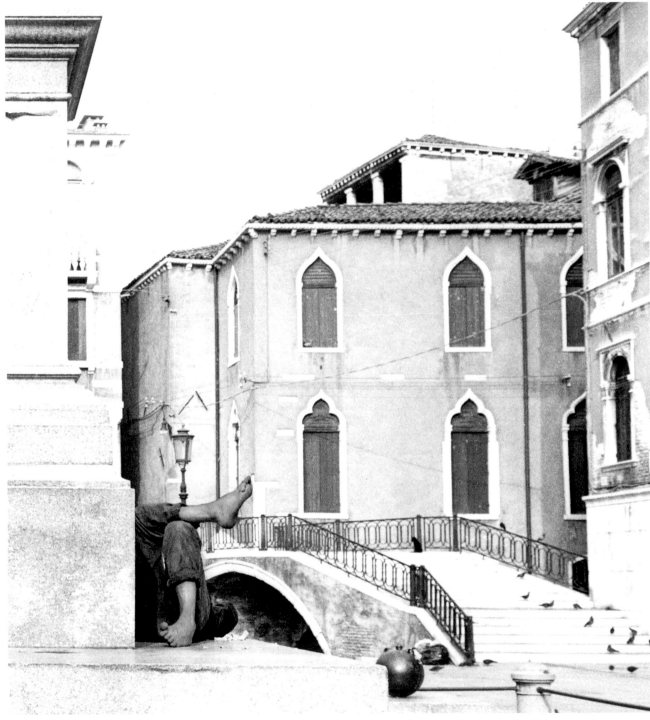

Venice, Italy 1994

Making the lazy legs lively by introducing color into the scene with photo oils.

72

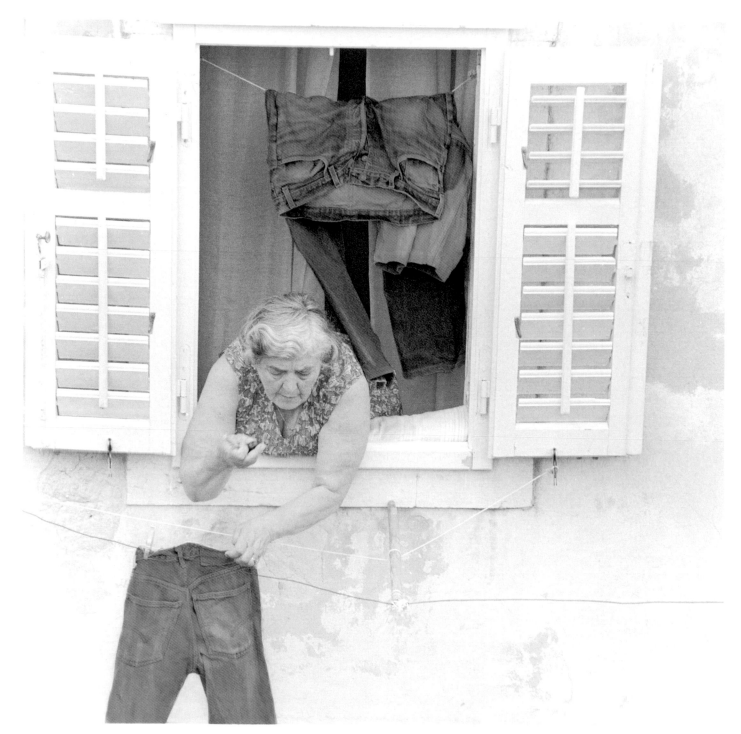

Dubrovnik, Yugoslavia 1990

The photographer gets to choose what colors to make the clothes on the black-and white print!

Photo oils are worked into the matte silver paper print, (matte rather than glossy paper holds the oils in) and the transparency of the photo oils allows the details to come through in the image.

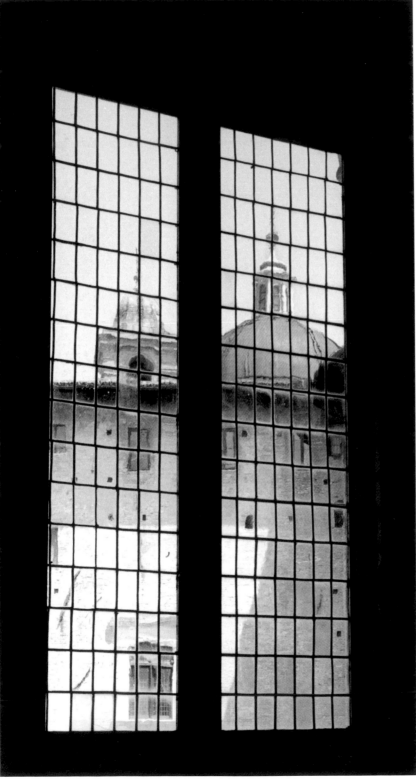

*A chiaroscuro image, but the photographer has imposed color
back where it was once seen from inside Raphael's house.*

Urbino, Italy 1993

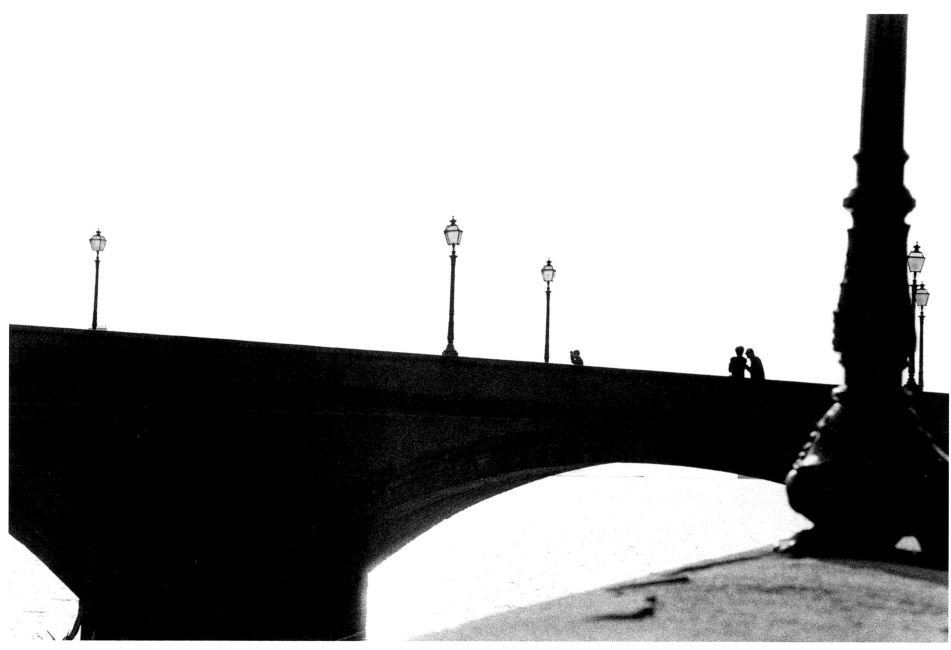

Florence, Italy 1994

A delicate touch of color provides points against the sky.

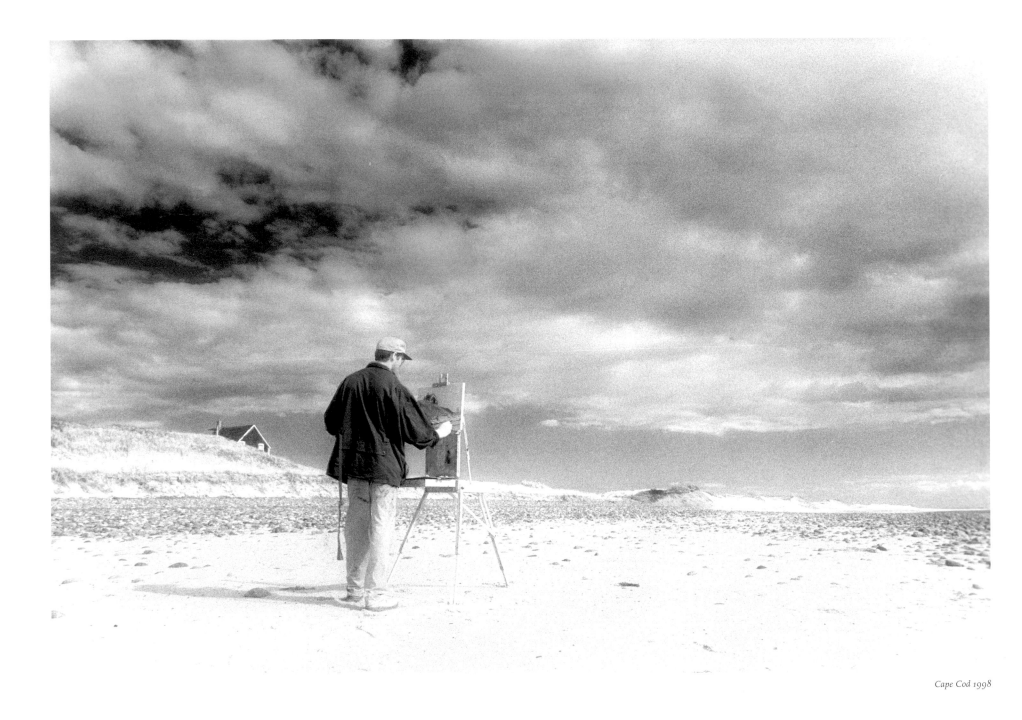

Cape Cod 1998

The photographer becomes a house painter, using photo oils to put the red back in the scene.

The painter is on the beach, his subject is on the dunes, and the camera is loaded with infrared film.

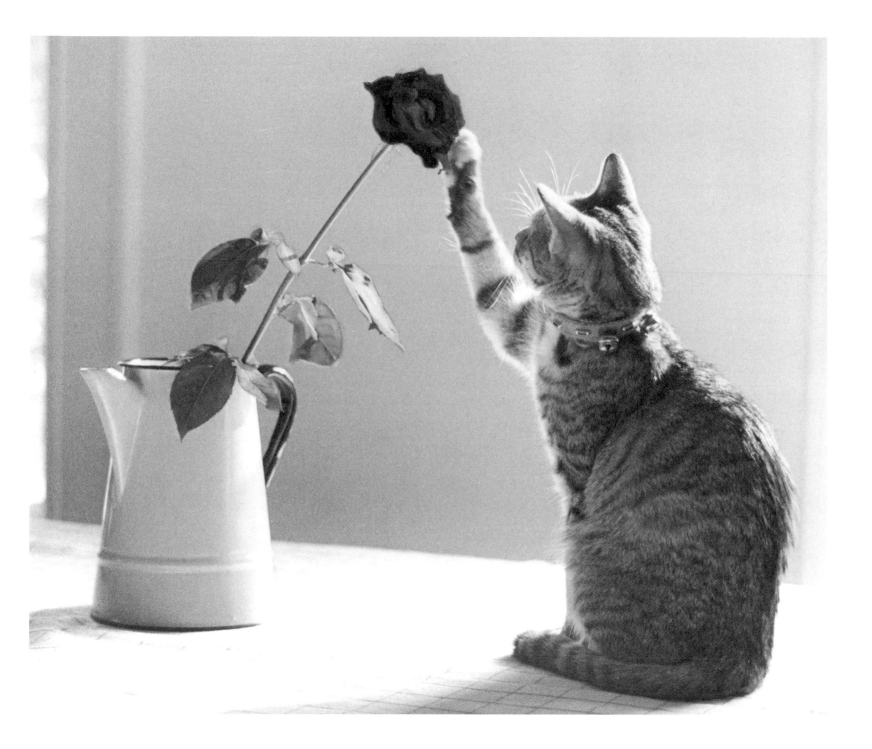

Tzipi is happier with a red rose, though the original rose was yellow! Created with photo oils on a black-and-while print.

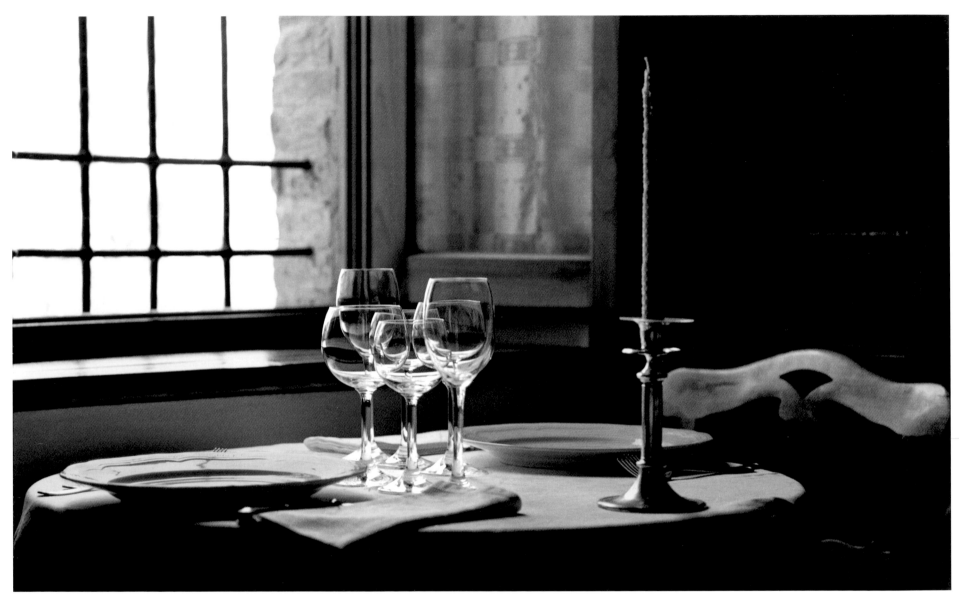

Urbino, Italy 1993

An experiment: How will making those dishes green affect the scene?

Nothing gained if not tried.

78

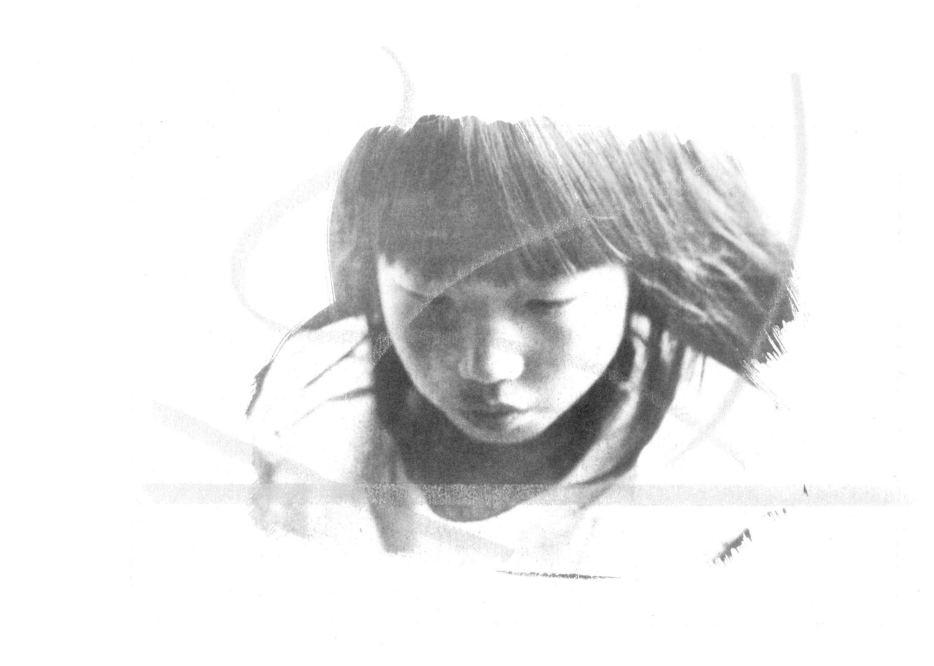

Japan 1982

Platinum emulsion is brushed onto pastel cloth and printed with the enlarged film negative in a contact print frame. Then, a few swirls of pastel crayon on the print provide a simple enhancement.

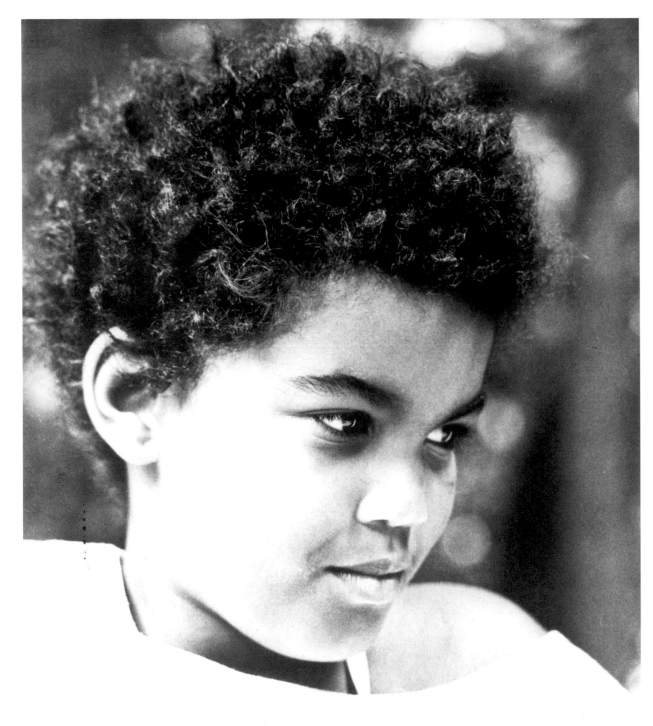

Such is the intrigue of joining certain chemicals to make a light sensitive solution that permeates deep into the fibers of the paper to create a portrait!

The rich brown of the Van Dyke print (named for the brown oil paint of the Flemish painter) is yet another silver process (besides Albumen and Salt printing) going back to the early 1840s. The chemicals are Ferric Ammonium Citrate, Tartaric Acid and Silver Nitrate. It takes many trials to achieve the right density of the final print, but is well worth it.

Chemicals create a glorious Prussian Blue through a process used in the early development of photography.

The astronomer Sir John Herschel gave the process its name: **Cyanotype**, a method he discovered in 1852. The chemicals Ferric Ammonium Citrate with Potassium Ferricyanide are brushed on paper and placed with the enlarged negative in a contact printing frame and exposed to ultraviolet light. It may take many hours of experimentation to achieve just the right blue by using exact proportions of the chemicals and the correct length of exposure to the light.

This print could not have been made without eggs!

An albumen print has a coating of egg whites, giving it a smooth, lustrous surface, a method used for 50 years before being replaced around 1895 by gelatin paper. This process gives the image a long tonal range, and unlike gelatin is impermeable to water.

Recipe: Beat egg whites to a froth and refrigerate for 24 hours until liquefied. Add distilled water, Glacial Acetic Acid and salt, and let cure in the fridge for a week. (Make a cheese cake with the yolks and eat it slowly in the meantime.) Add Silver Nitrate and coat the paper. Contact print the paper with an enlarged negative and expose to ultraviolet light. What exacting and arduous work the early photographers went through, appreciated when one goes through the process oneself.

Much history behind photographic processes

came about through experimentation, leading

to discoveries of the effects of light working on

different photographic chemistries. Using the same

image, one can have a new visual and emotional

experience with each, depending on the process used.

The results of these cannot be achieved digitally.

The print needed the gift of platinum with its velvety, luminous tones, and long tonal values.

Platinum printing was one of the earliest processes, a medium lasting forever and seeming to take forever to perfect. Once developed the image consists of pure platinum. Today the chemicals are obtained through suppliers, as some platinum practitioners remain.

The print could not have been made without salt.

Salted prints acquire a beautiful delicacy in the lighter tones. In the beginnings of photography Fox Talbot discovered the light sensitive effect of salt on silver. Paper used to be "sized" with starch or gelatin so the solution wouldn't sink into the paper's pores making the image less sharp. Laundry rooms of photographers had sized paper hanging next to the diapers, and photographers' fingers had the tell-tale black of the (poisonous) silver on them for days. Worse yet was the potassium dichromate they used for contrast. They learned to use rubber gloves.

Platinum printing...
the prince of photographic processes.

ALFRED STIEGLITZ

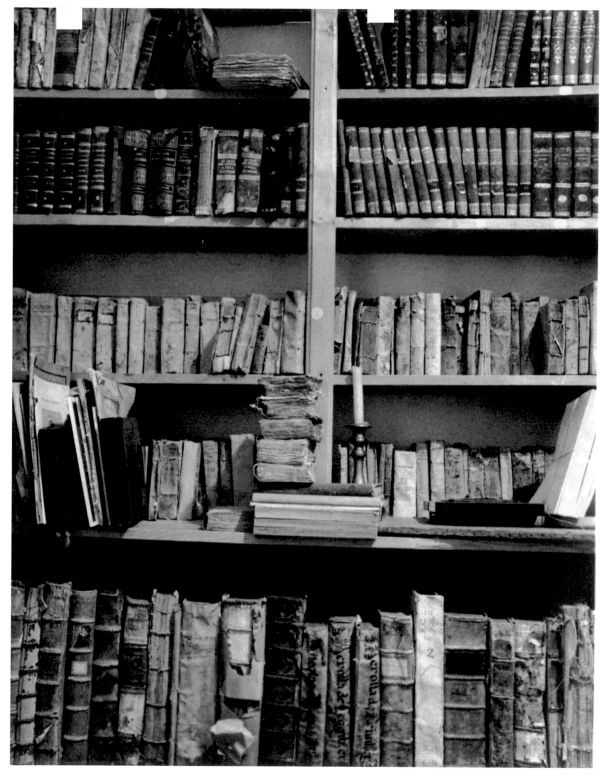

Biblioteca Ivan Pastric, Split, Croatia 1991

The textures of the musty, vellum-bound volumes in a small, windowless seminary library call for platinum printing which gives a wide spectrum of tones: deep shadows, delicate middle tones, and luminous highlights. The platinum print lasts forever, as will the books too, one hopes.

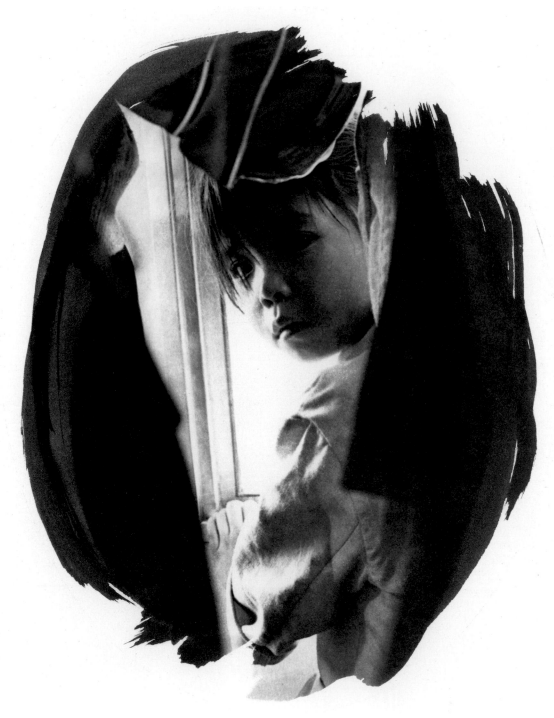

With the brush, "...imprisoning reality."
SUSAN SONTAG

The Platinum solution is combined with iron to become
light sensitive, then brushed onto paper. The enlarged
negative is sandwiched between the sensitized paper
and glass in the contact printing frame and placed under
ultraviolet lights. The Platinum solution bonds with
the iron, becoming metallic Platinum so the image
prints out.

Tai Shan, China 1982

88

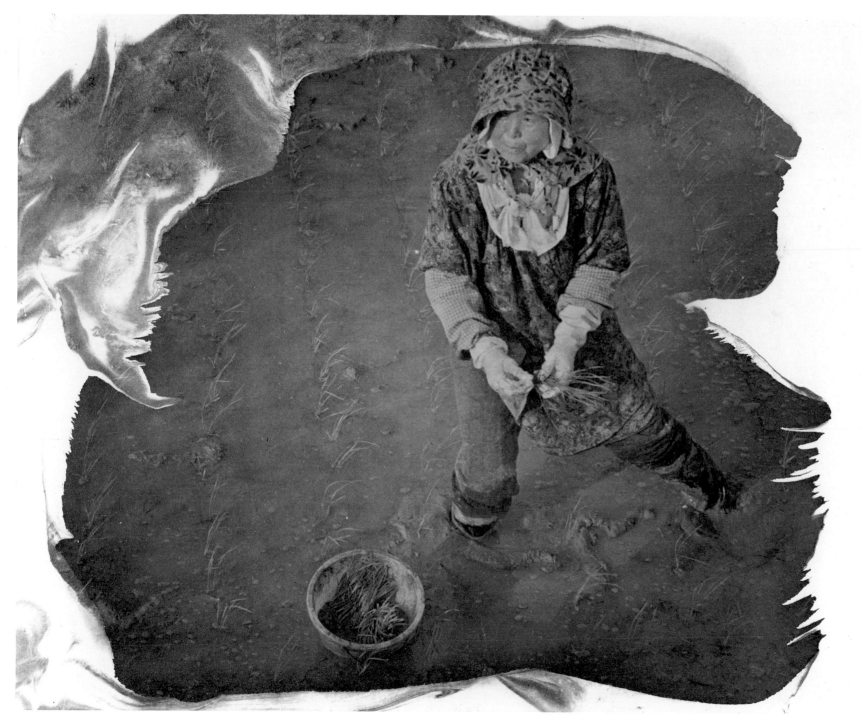

Sanda, Japan 1992

Eastern mysticism created by chance in the darkroom.

Surprises revealed in the development bath when the print was lifted out and the platinum emulsion was unwilling to leave the paper. A mistake to be preserved!

Is the brush creating the image?

With only three brush strokes of the light-sensitive Platinum solution on the paper, the enlarged negative is placed against the paper and exposed to ultraviolet light. The image will appear only where the light-sensitive solution has been brushed on the paper.

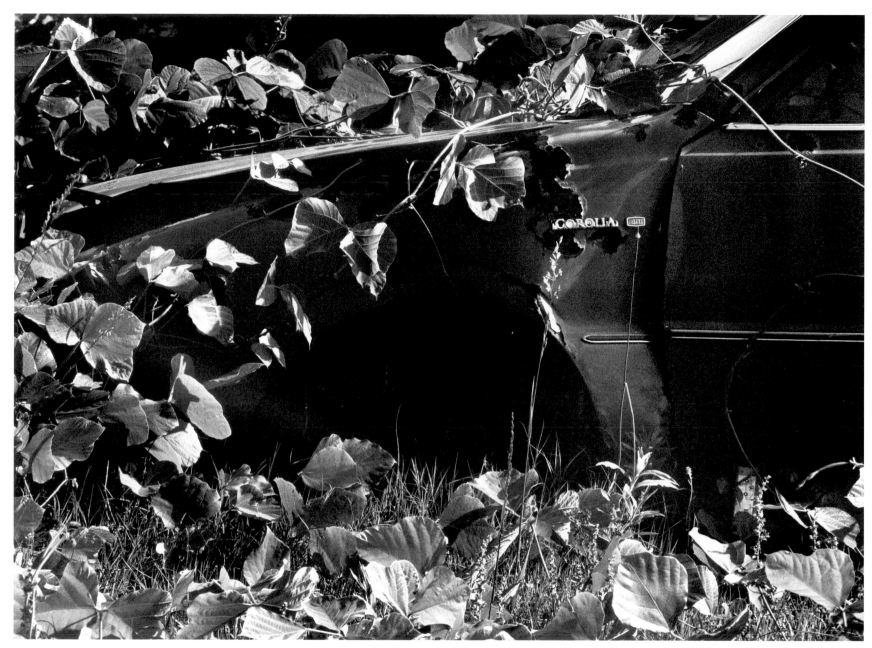

South Carolina 1989

An abandoned car and a rapacious vine can become a portrait, before it all becomes something else.

For a more vegetative feel, the print is toned with sepia chemicals that contain sulphur (Sodium Sulphide) which tests a photographer's tolerance to remain in the same room with the fragrance of rotten eggs. But being involved in the actual physical process is somehow satisfying, despite the smell!

1982

Light and textures inspire a photographer to compose something for the camera and wonder how it will come out in the print.

One achieves an extraordinary warm hue using Agfa's Portriga silver paper, a paper much loved by photographers. Alas, along with most other silver papers, it is no longer available and digital photographers have tried to emulate its unique quality.

A door that has a live power of its own, its past and its present life. A door with a personality! The camera reads its parts. Photography will preserve it further, at least its image.

A door perhaps as old as Guanajuato itself, for centuries a silver mining center for the Spanish crown, and the birthplace of the great painter and muralist, Diego Rivera.

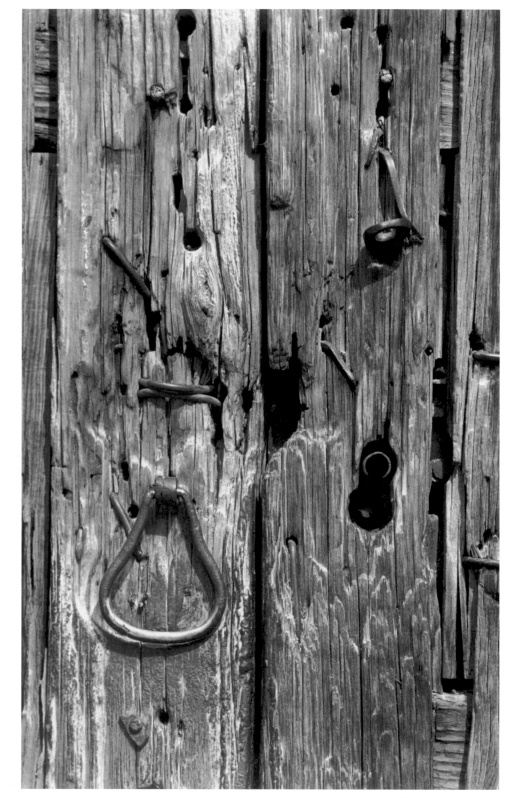

Guanajuato, Mexico 1988

93

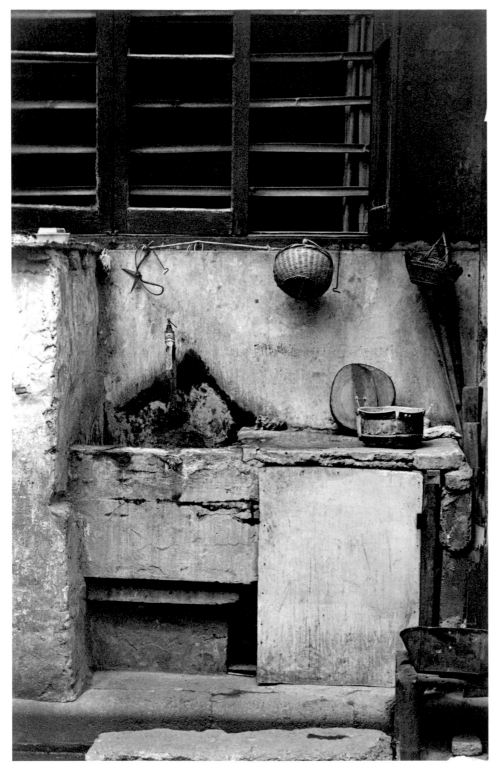

Shanghai, China 1982

Here in the outdoor kitchen, attention must be paid to the textures of stone, metal, and reed, as well as to the residents of this thriving neighborhood.

Alas, most of the Lilong neighborhoods have been razed now, their residents forcibly relocated to high-rises, where there is little street socialization. Such relocation is part of China's drive to westernize, modernize, and create an expanded economic system.

*Some subjects
take possession of
a photographer...*

The irresistible impulse to play with images.

Platinum solution is brushed onto yellow art paper to print out the portrait. Then, unwilling to leave well enough alone, why not give the subject some more adornment from a bit of nature?

A cluttered studio impels the photographer to go hunting for whatever strikes her fancy to play with a favorite image.

A photograph made
without a camera?

and other photographic surprises...

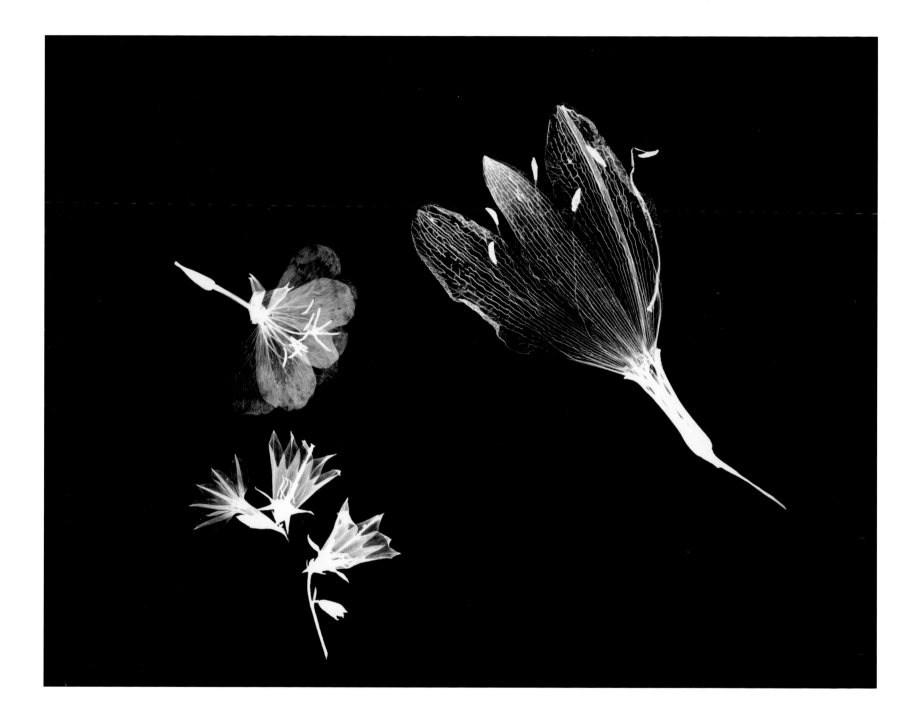

Accomplished by placing objects onto light-sensitive paper which is then exposed to light, the process was called photogenic drawing by Fox Talbot in the beginnings of photography. In the 1920s Man Ray made artistic images of geometric abstractions he called Rayographs, partly after his name, partly after their resemblance to Xrays. Here, the flowers are placed upon silver printing paper and exposed to the enlarger's light, after which they are removed, and the paper developed and fixed.

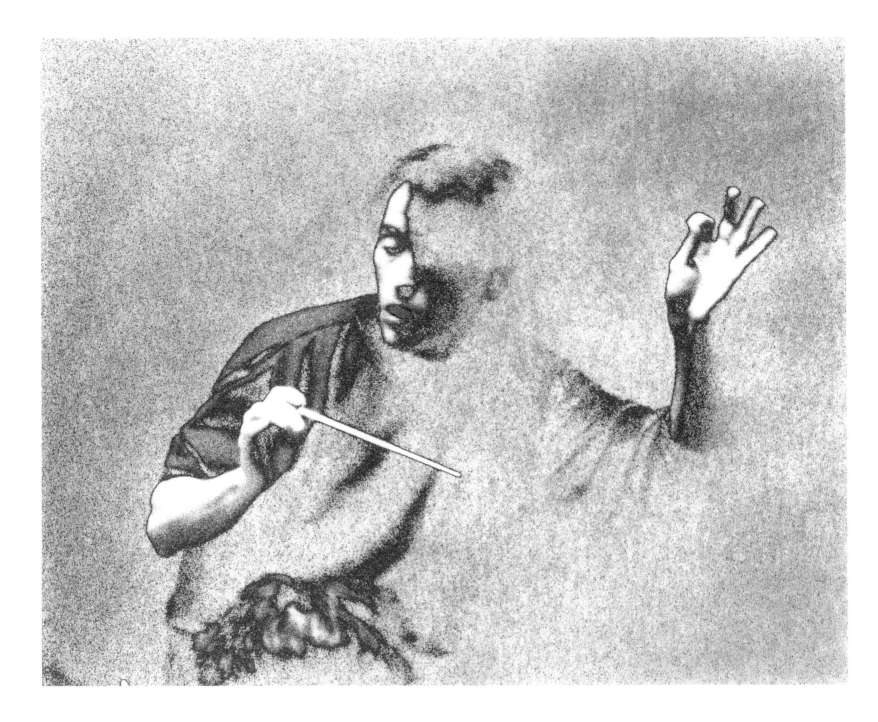

Undoing the image for the sake of its defining parts.

Mordançage: a process dating from the late 1880s. A photographic print is put into an acid copper bleach which dissolves away parts of the metallic silver image. When the print is put back into the developer it becomes part negative and part positive. The darker the area, the more dissolution. No two results are ever the same. It's a frustrating, messy, smelly, and unpredictable process, and can be quite wonderful, but is best worked with outside with plenty of fresh air and a water hose.

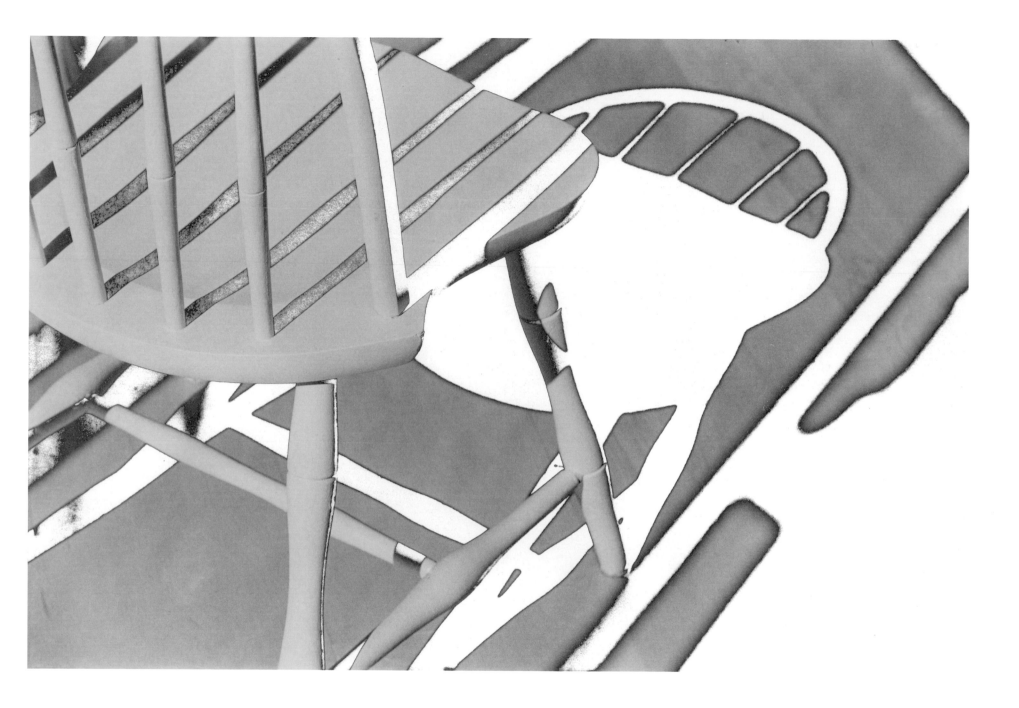

Experimenting yields surprises. The process is again **Morgençage**. It works best with prints that have large shadow areas that will become partially reversed in the process, as was the shadow of the chair which became a white shadow! Acid dissolved lots of metallic silver which could then be lifted off the paper. The dissolution is caused by the combination of the Copper Chloride, Peroxide and Glacial Acetic Acid.

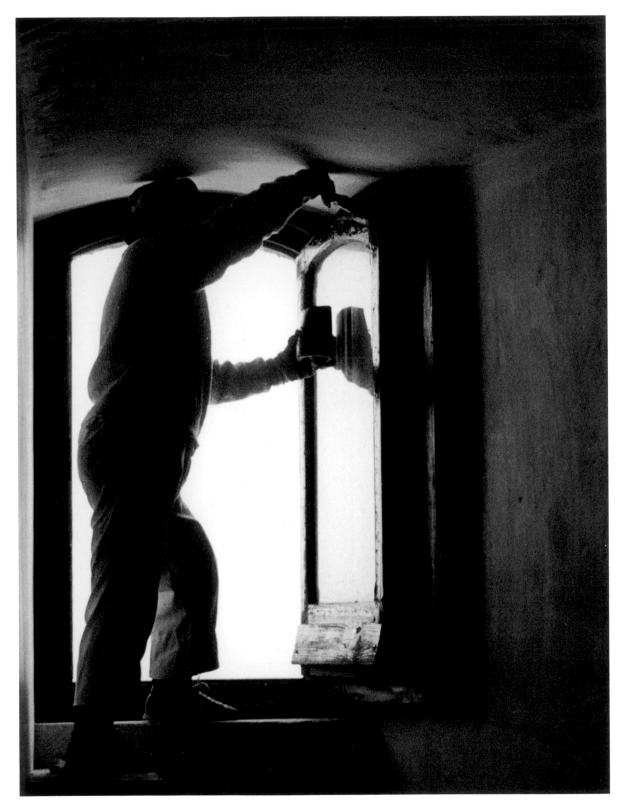

The man has framed himself into a photograph, irresistible
to an acquisitive photographer.

Belmonte Castle, La Mancha, Spain 1991

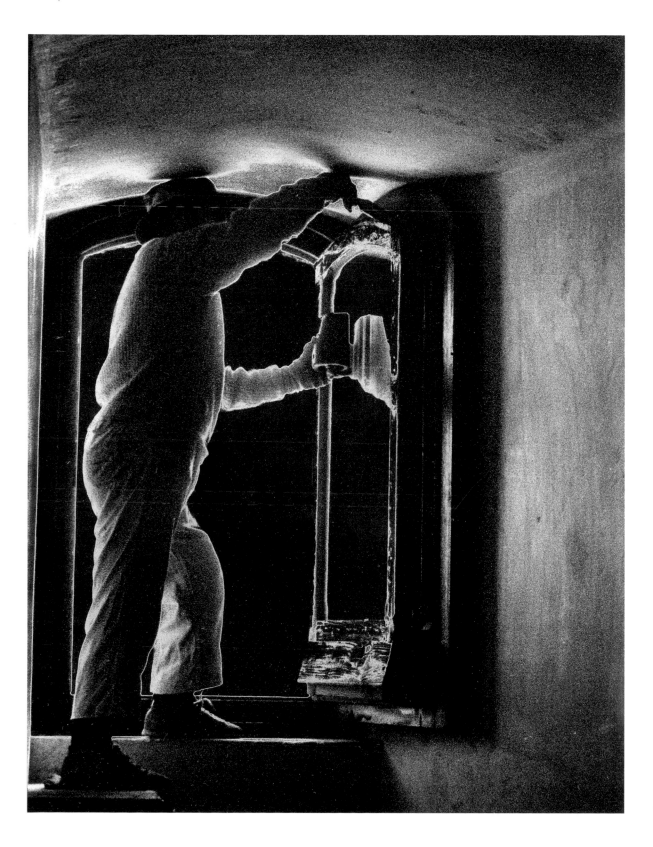

A new process called SOLARIZING *was probably discovered by accident when someone entered the darkroom unannounced.*

It is also called the Sabatier effect after the French scientist who first described it in 1862. The print, lying in the developer, partially developed when a light is briefly turned on, and the image becomes partly positive and partly negative, leaving distinct white lines between the light and dark areas called Mackie lines (after Alexander Mackie in 1885). These lines have a graphic beauty of their own, as the bromides in the silver paper collect around the contours in the image. Solarization is correctly an extreme exposure of film in the camera, causing the film to reverse and can turn the sun's image black.

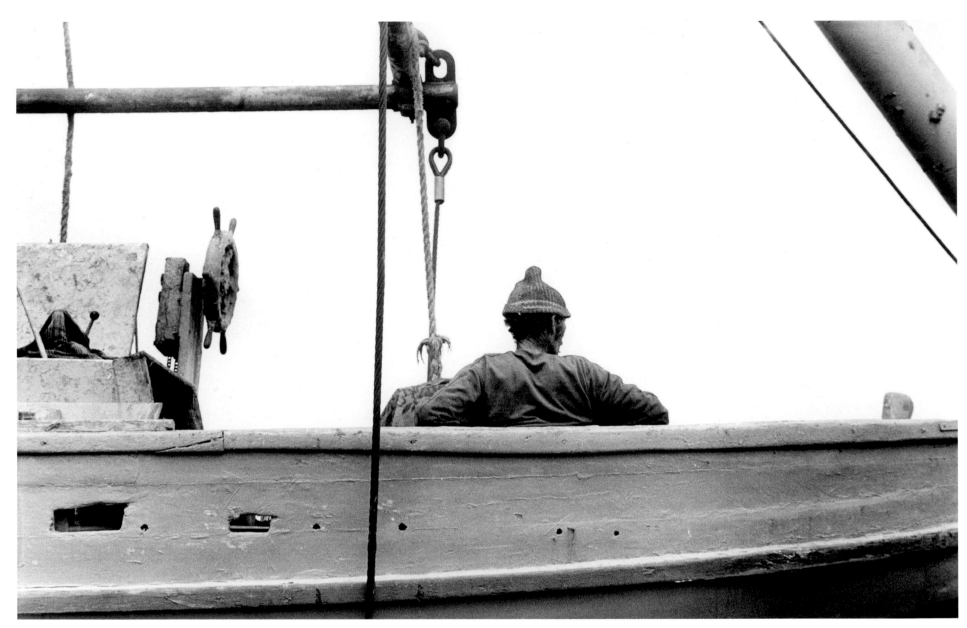

Jaffa port, Israel 1991

A study in form as content.

The many angles are brought out by printing with as much contrast as possible making the geometric forms striking against the white sky.

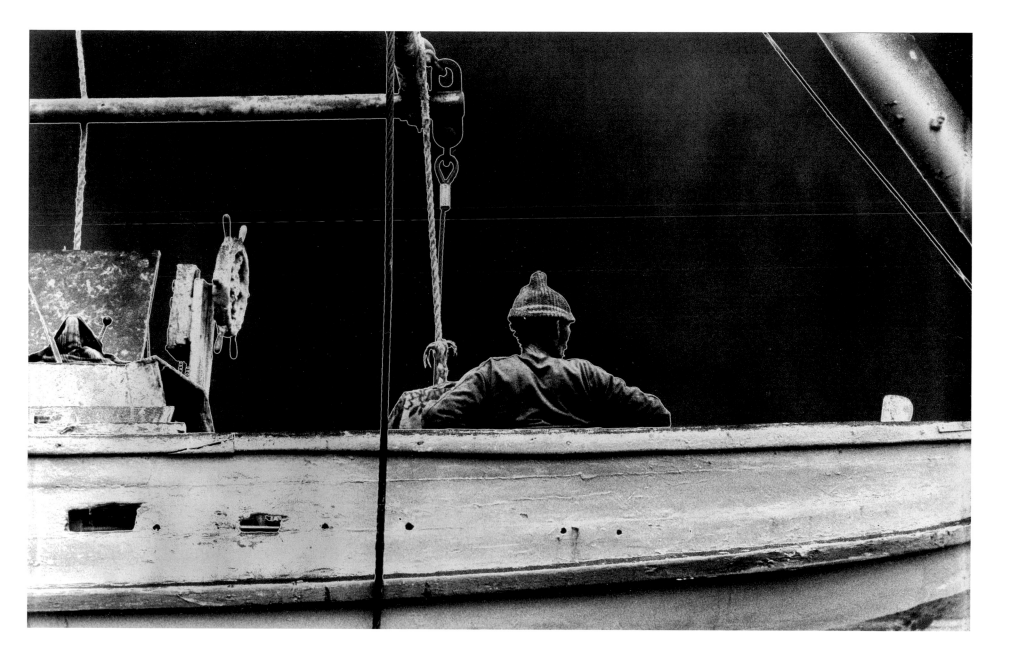

The photographer needs a good breakfast before entering the darkroom for a few hours work "Solarizing" (or Sabatiering) the image.

There are many variables to deal with and careful notes to take to achieve the desired effect:

The type of original image
(strong and simple lines are best)
The kind of silver printing paper *(bromide is best)*
The length of time of exposure under the enlarger
The kind of developer *(Solarol is best)*

The length of time the print is in the developer
before the light is turned on
The strength of the light bulb
The length of time the light is turned on
Lunch can wait.

Animals

are caught

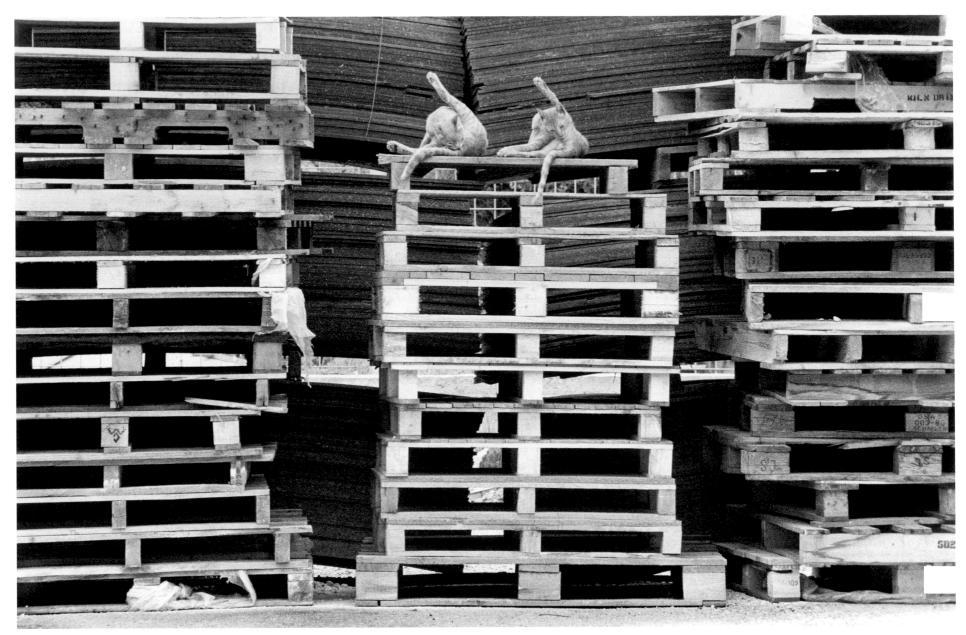

Jaffa port, Israel 1991

The ZOOM *lens,*
"A tireless hawk swoops on its prey...
and brings it back to its master."
MICHAEL TOURNIER

The **zoom** lens is often used by photojournalists. It allows one to make images from a distance without disturbing or being involved in the action. The cats are enjoying a choreographed bath after finishing a tasty meal by the port's fish restaurants.

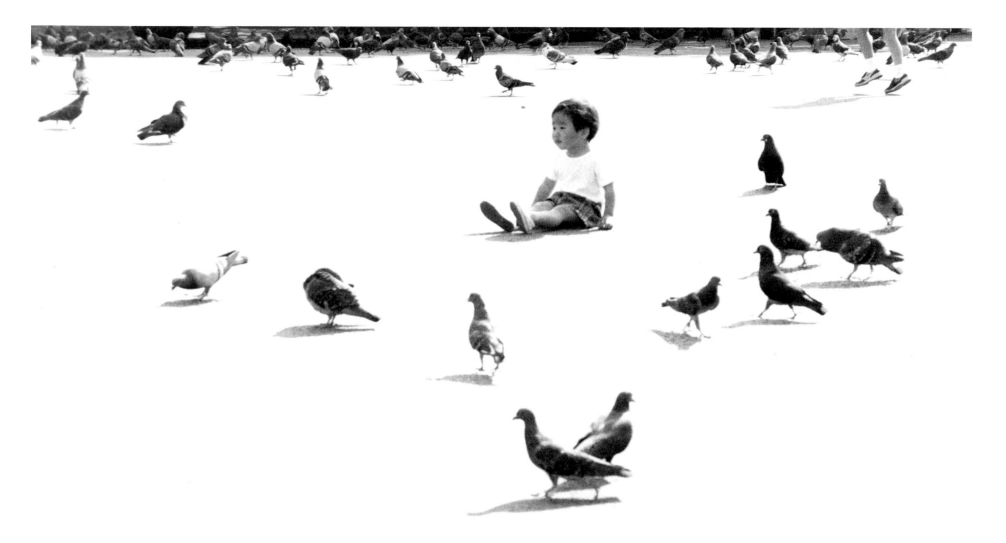

Oeno Park, Tokyo, Japan 1992

The camera is at child and pigeon level, from a non-disturbing distance.

Preserving the shadows of the pigeons and the runner's feet (discovered only later in the print), along with a child's sense of wonder.

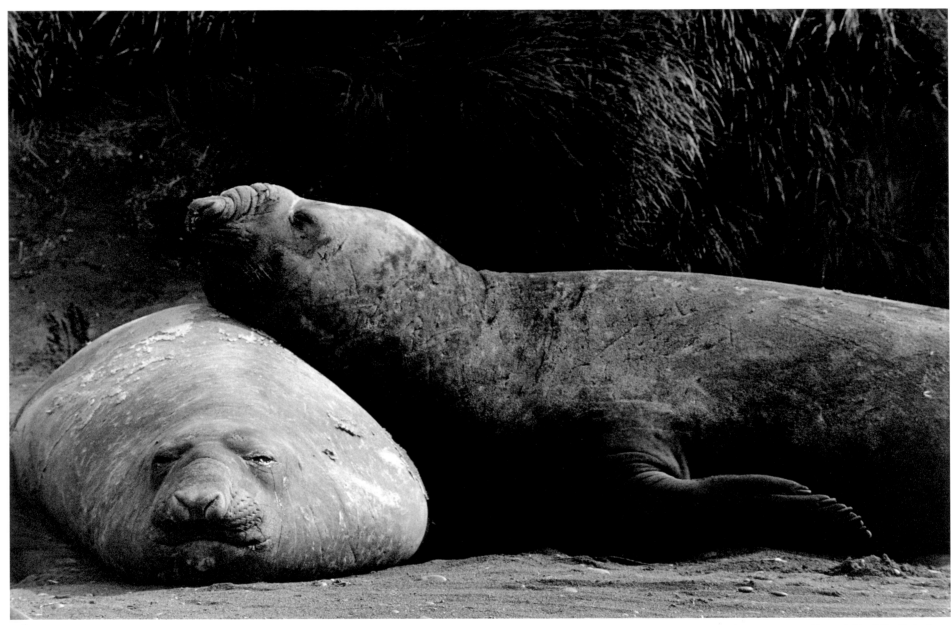

An intimate portrait of elephant seals, although people are warned to keep their distance!

But the camera's **zoom** lens manages to get as close as it wishes.

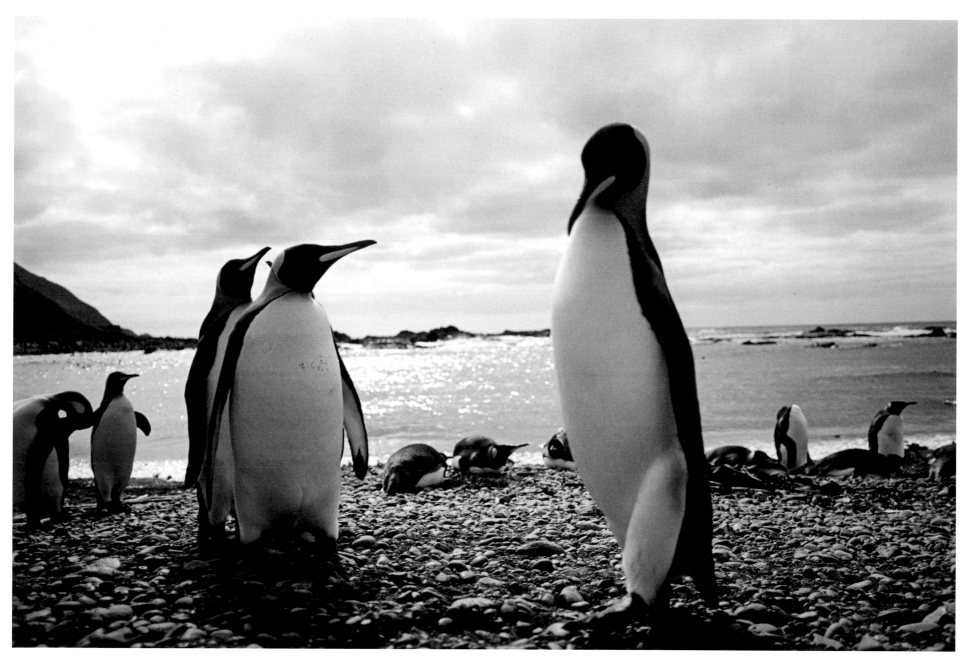

Macquarie Island 2003

Unlike with the elephant seals, these penguins permit a close encounter. But one needs to be respectful so as not to disturb their dignity.

The beautiful is always strange.

BAUDELAIRE

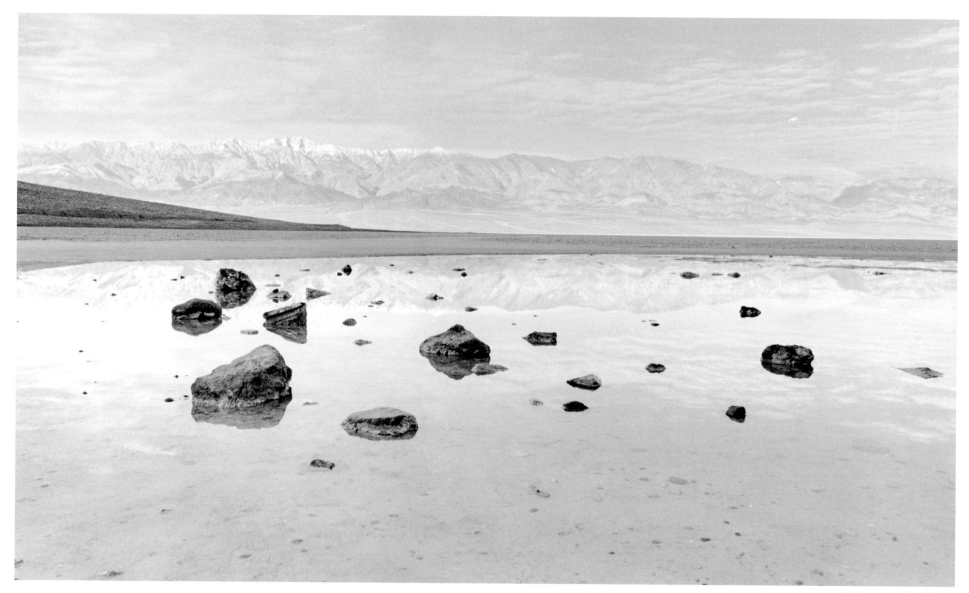

Bad Water, Death Valley 1991

Nature can be surreal. A wide-angle lens captures this
strange place, some 282 feet below sea level, the lowest
on the American continent. The salt crust is three to five
feet deep here, with only a few inches of spring-fed water
on the surface, enough for a reflection of the nearby
rocks and the mountains in the distance.

Negev desert, Israel 1998

Stop the car! And there is the lovely acacia standing alone in the vast Negev desert.

Acacias are the only trees in this desert and are said to be the most isolated tree in the world. When spotted, photographers make good use of their distinctive shape against the empty landscape.

The mystery lies in the withholding.

Examining the test prints of a series of enlargement timings, one may see other possibilities, so here the print is intentionally underexposed (light withheld) for the effect. Then, adding the chemical Hydroquinone to the developer produces more contrasting tones, yielding an almost graphic effect.

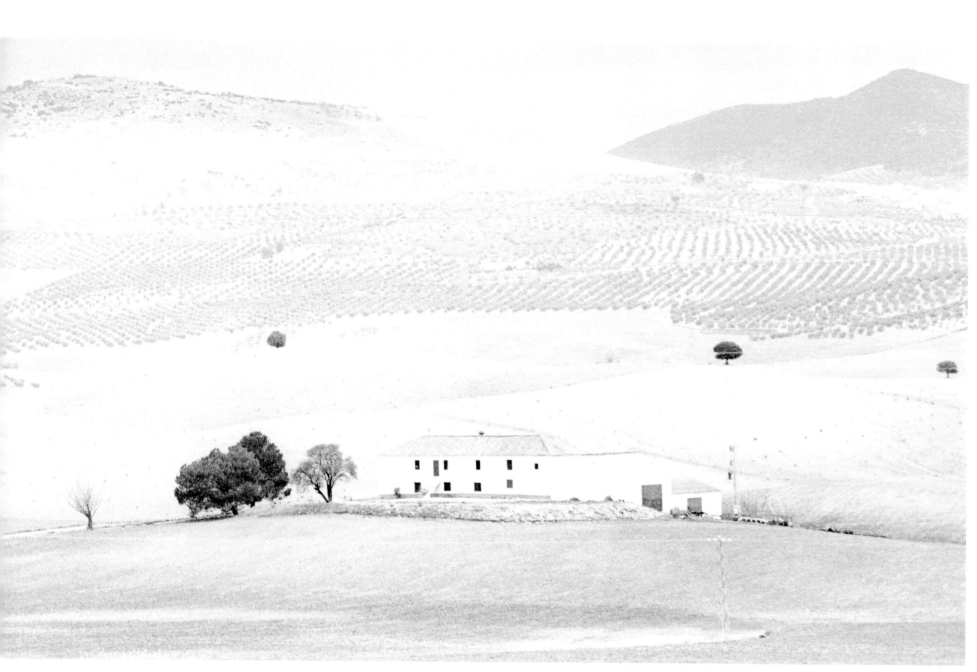

Baeza, Spain 1996

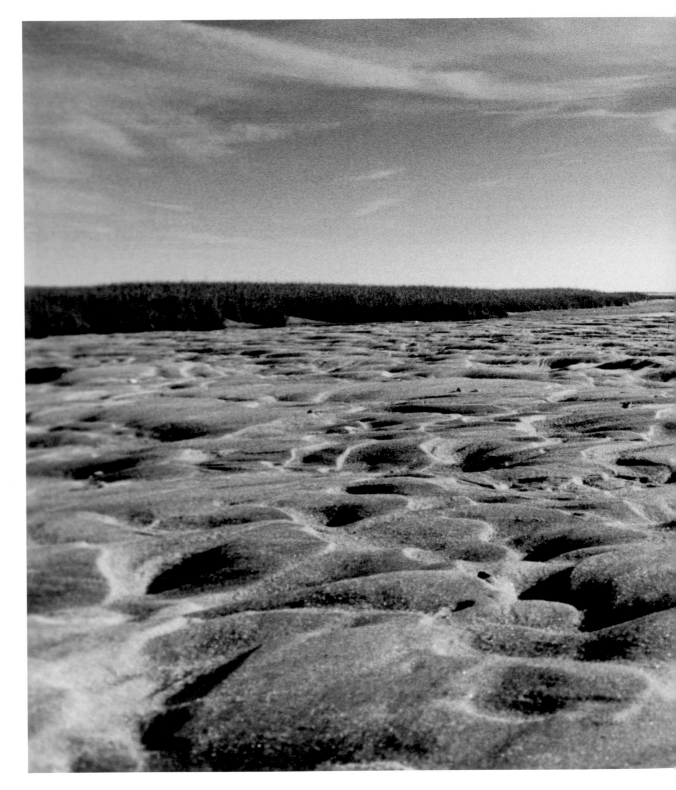

Going for intentional distortion with the wide angle lens to give an altered reality, while every detail within the lens' vision is registered sharply! The results often surprise the photographer.

The photographer is lying prone on the salt flats with the short, wide angle lens on the camera which takes in more of the scene, and keeps both the foreground and distance in focus (the Depth of Field). A very small aperture (F stop) on a normal lens would increase the depth of field as well, without distorting the foreground, but would not give the expanse of the scene, nor allow as much light through the lens.

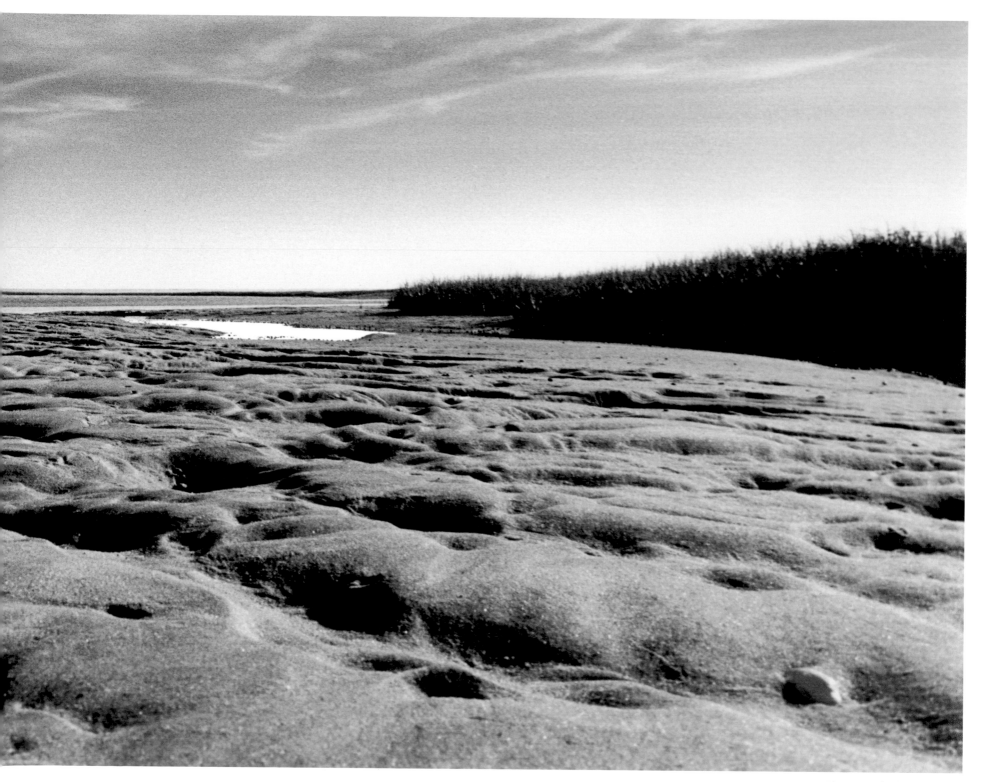

Lieutenant's Island, Cape Cod 2000

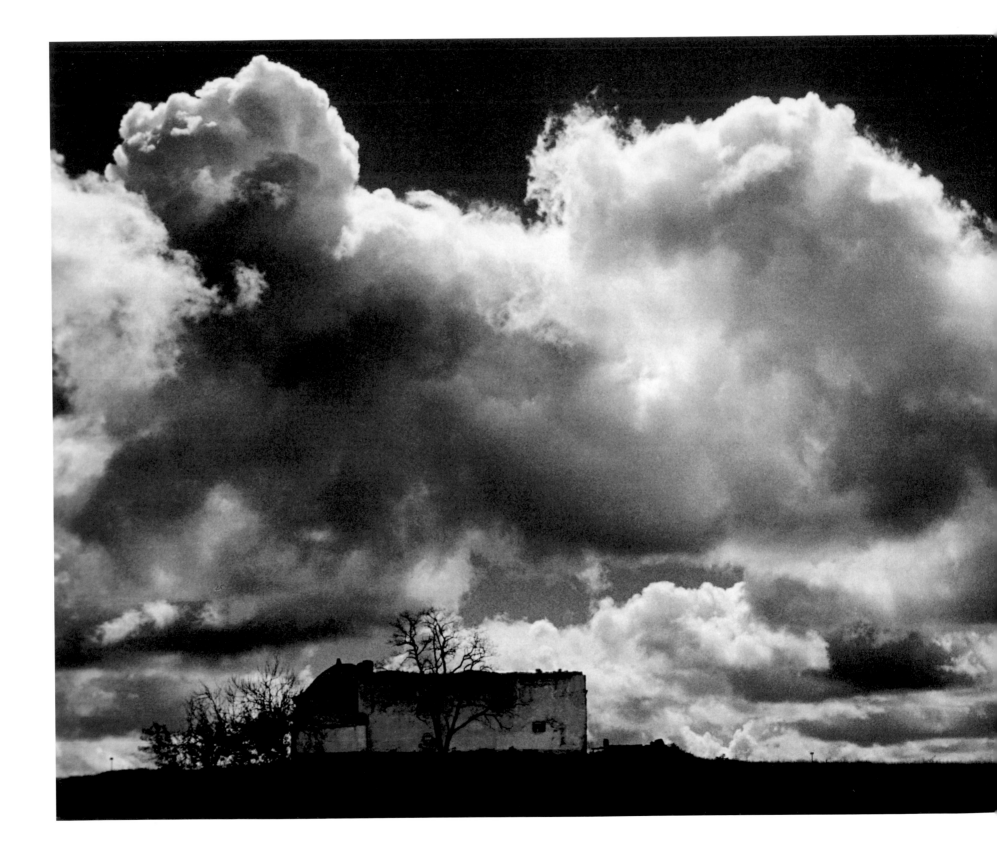

Estremoz, Portugal 2002

A storm is brewing. For more drama a red filter on the lens makes the sky even darker against the clouds. But there are problems to work out.

The barn prints out too dark and needs some light-dodging under the enlarger. So a thin cardboard template is cut the size of the barn and placed on the silver paper where it will print out under the enlarger. The template keeps the light from reaching this area but is withdrawn when the barn too needs to be exposed, but for less time than the rest of the image.

Trial and error means a few hours work in the darkroom. Of course it can be done so easily with digital functions!

Death Valley, California 1991

Two leviathans meet here in Death Valley. The dunes create illusions.

The photographer must choose where and how to place the camera to achieve what the eye sees and desires to capture in a photographic image.

Cape Cod 1985

What was the camera thinking? While its mechanics are logical, the photographer must sometimes override its logic.

The camera's meter reads a middle value, a gray exactly between black and white. But if the snow is to be white in the print the photographer has to overexpose the scene so as to let in more light on the negative. More light leaves more silver (black) on the film, which will give a proper white snow on the positive print. Following Ansel Adam's **Zone System**, one visualizes the relative light zones from black to white in the scene, and places the snow in a high zone, implying that more light is needed than the camera's meter would indicate, which would have resulted in gray snow. Digital cameras have this figured out if one chooses an option for snow.

Is there *an art*

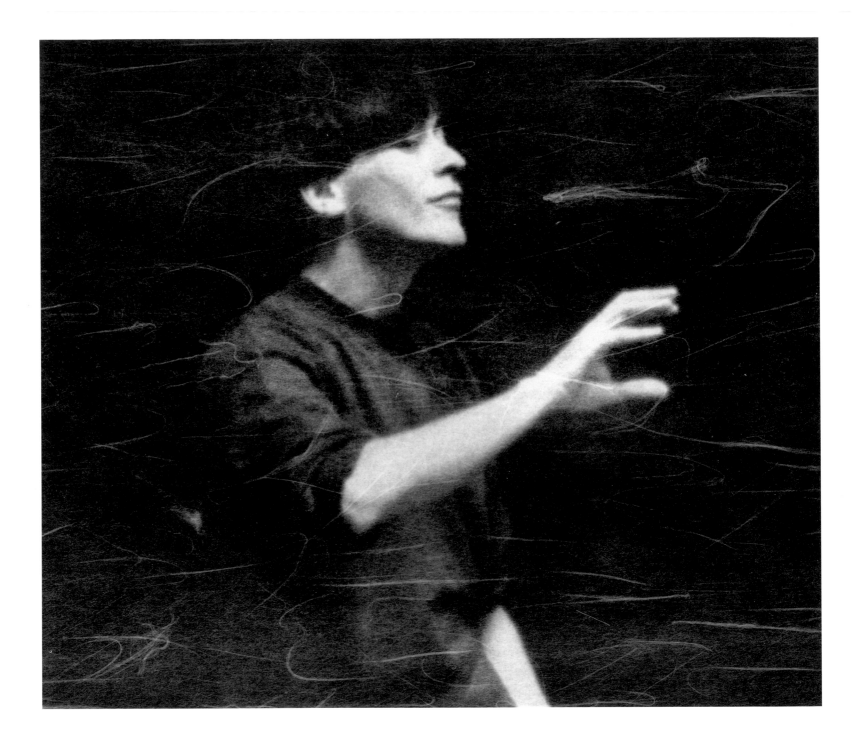

*Pascal Verrot, conductor. Overlays join the Platinum
images of Pascal's movements, imagining the sound of the
music he is conducting.*

126

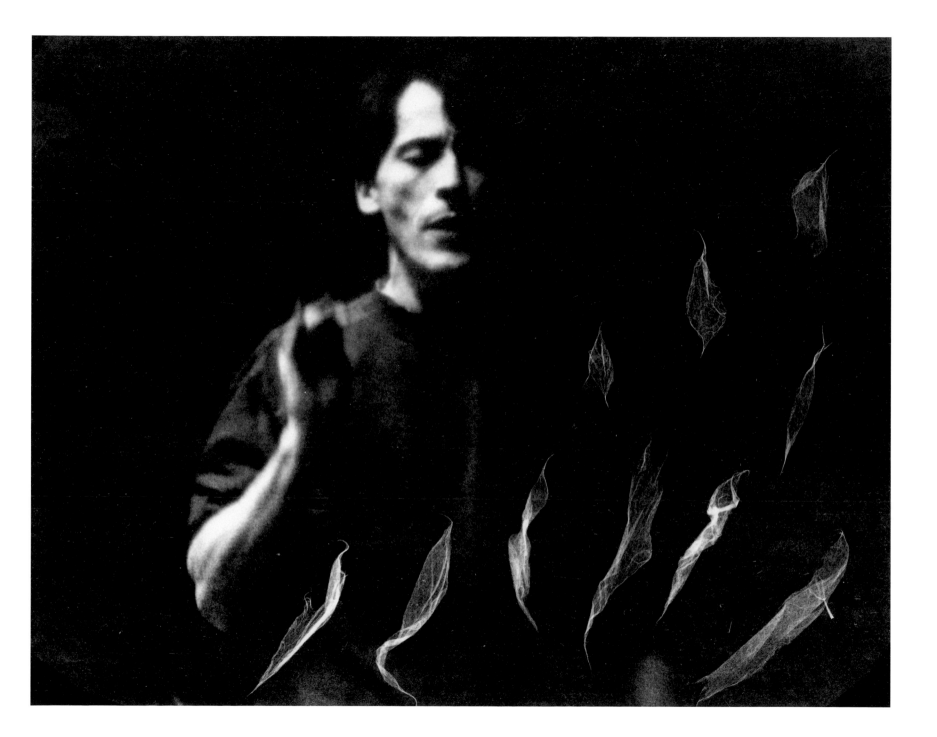

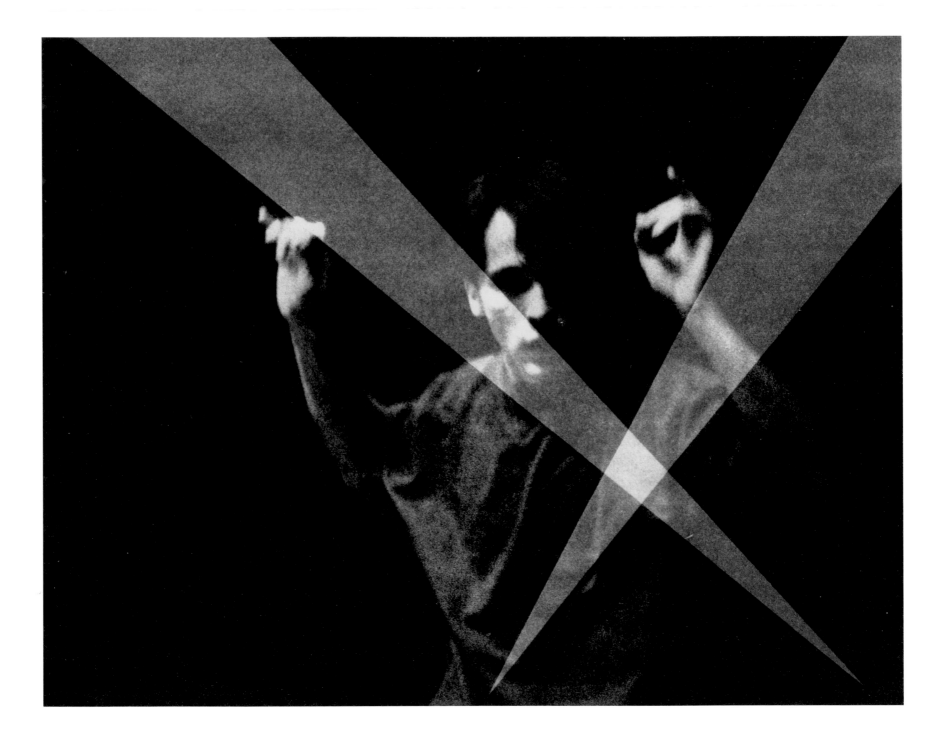

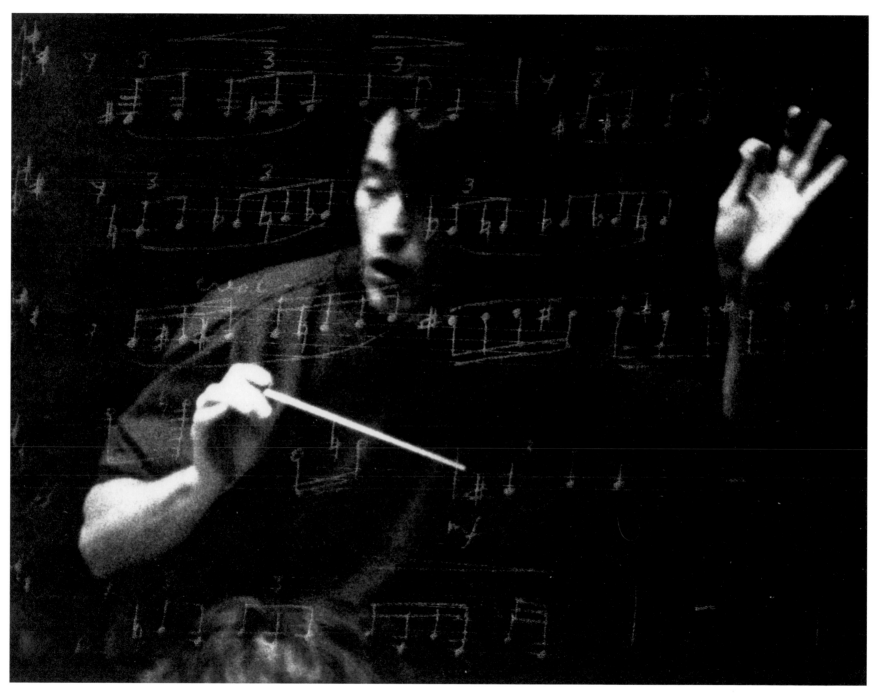

New England Conservatory 1989

Made with Platinum printing on rice paper and with overlays of milar and rice paper twists, and of course with experimentation, inspiration, perspiration, frustration, and revelation.

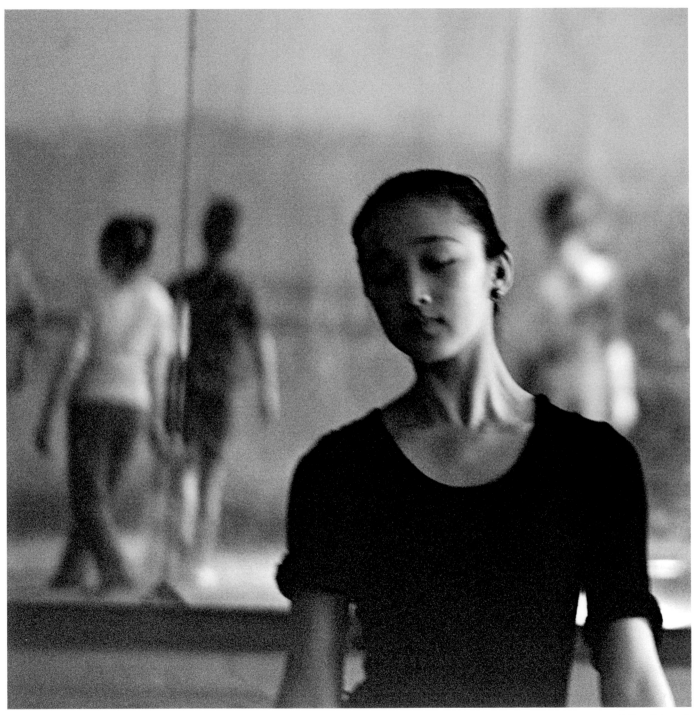

Beijing, China 1982

A fugitive vision, in her own artistic bliss, the camera expressing the majesty of a moment.

The lens, in that split second, takes in more than can any photographer's brain or eye.

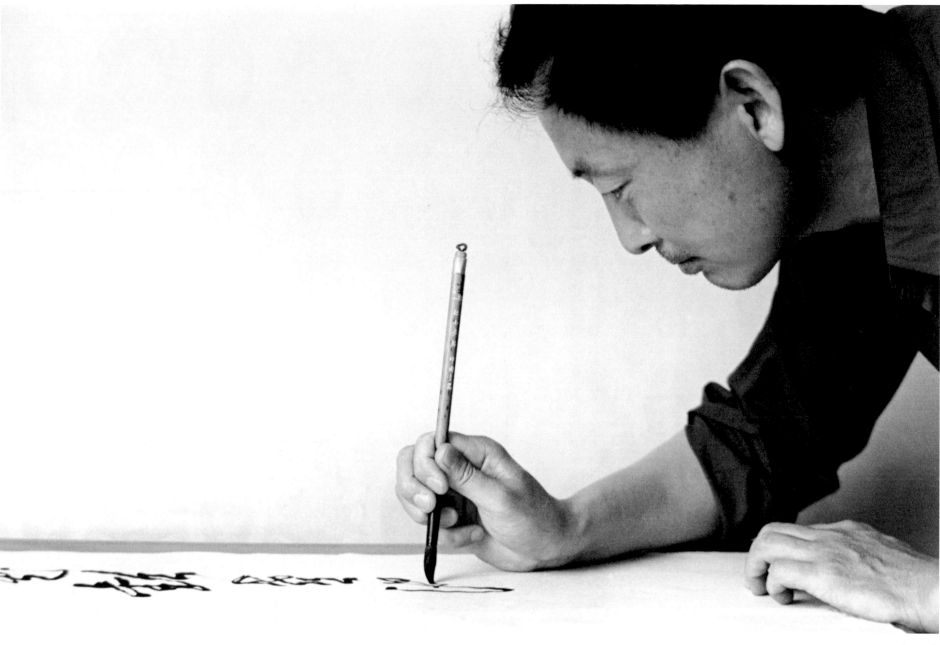

Tianjin, China 1982

Li Hengju, with his brush and soul, creates a gift for the image maker.

"Composition must have its own inevitability."
HENRI CARTIER-BRESSON

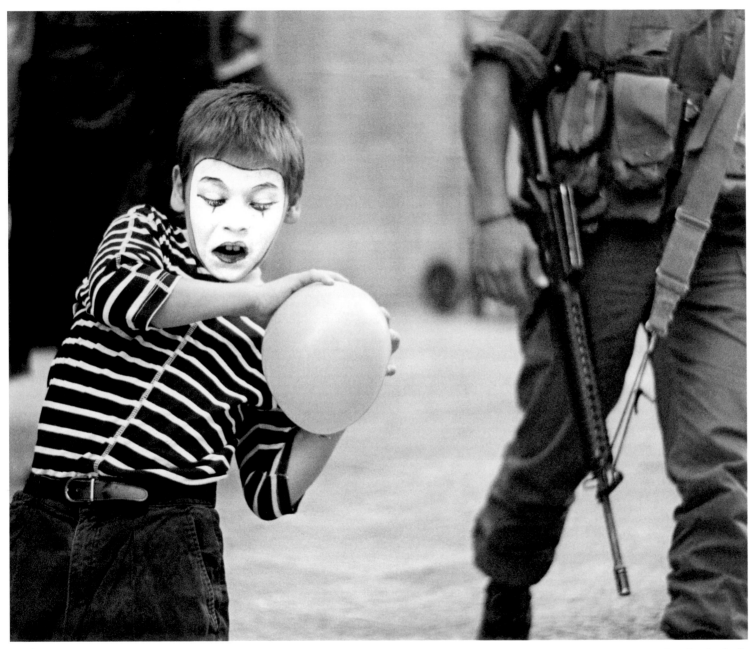

Jerusalem, Israel 1989

The camera can register ephemeral motion and create theatre of its own.

Boy mime and soldier: a surreal juxtaposition of play and war, brought together in 1/125 of a second.

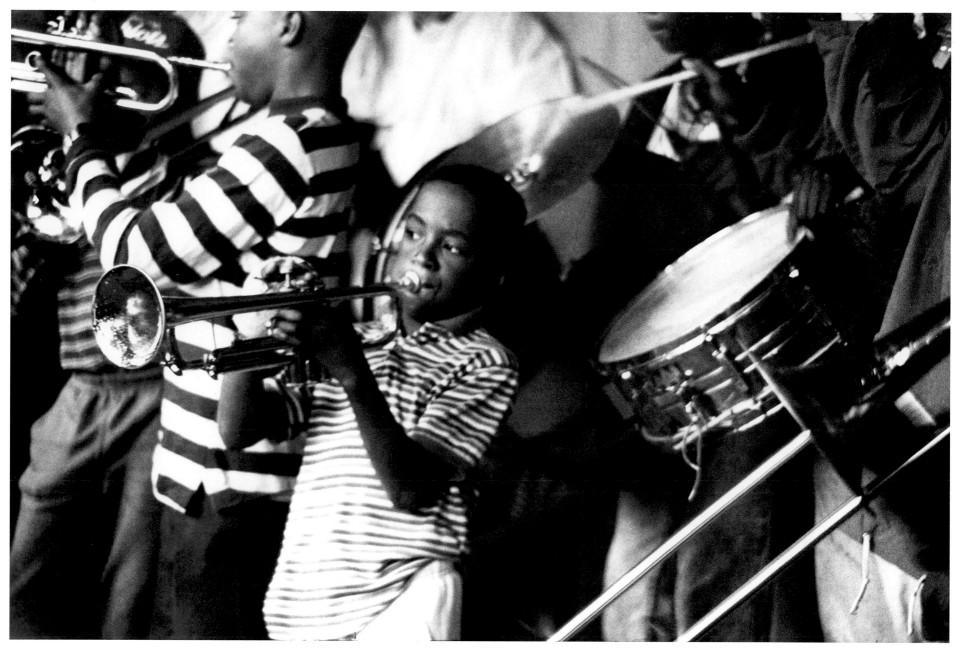

New Birth Jazz Band, New Orleans 1989

Time is stopped in 1/100 second, but the band plays on.

High speed film used on a dark, rainy day, allows for a fast shutter speed. This film has larger silver halide crystals. The result is a grainier image, a compromise worth making to avoid blurring the image with a slower shutter. The digital camera can be set for a "high speed", as if it was using this sort of film.

Spain—

The country of Don Quijote—
the brave bulls—

and the fiery sun
beloved of photographers.

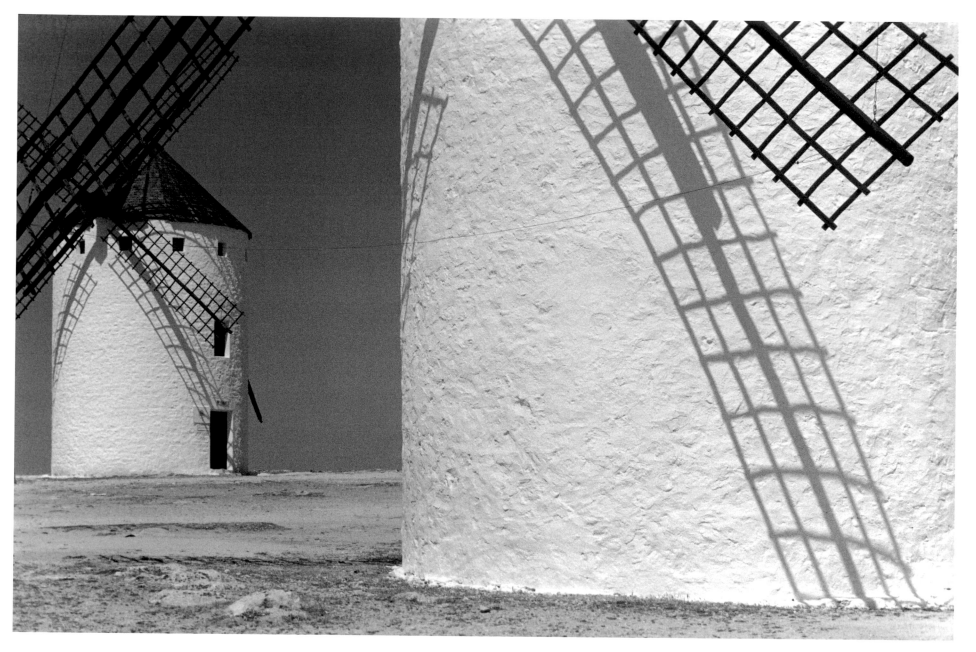

Moto del Cuervo, La Mancha, Spain 1990

The strong shadows beloved of photographers are arranged by the splendor of the Spanish sun.

From a distance here in the land of La Mancha, the windmills can indeed strike one as the giants of Don Quijote's imaginings near Dulcinea's town of El Toboso.

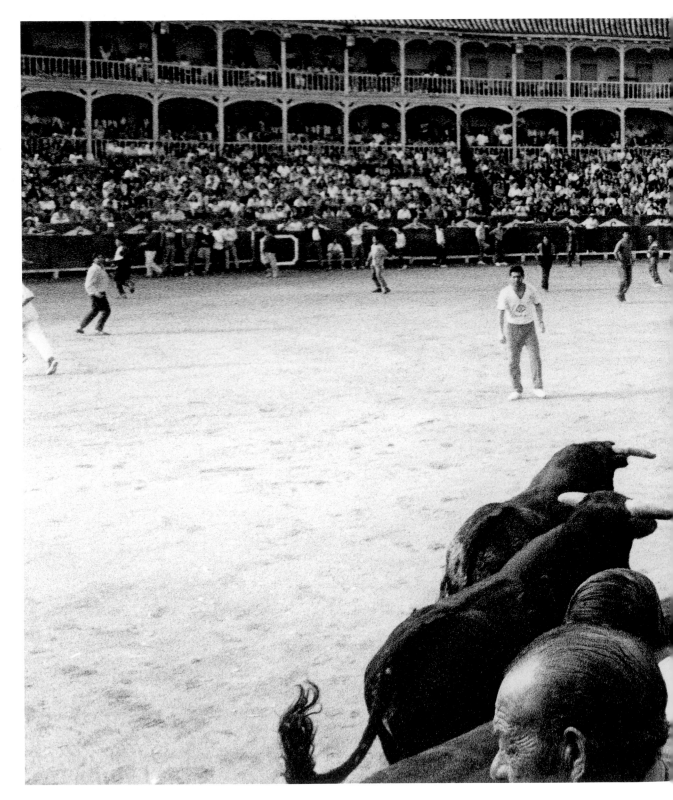

They are all loco: the boys, the crowd and the bulls they drive mad.

The photographer must make many instant choices: where to focus? What shutter speed to use? Every second the scene changes. It is a running of the bulls inside the bull ring, called an encierro, and the boys, with macho madness, get the bulls to chase them. The surprising grace of these huge animals only reinforces one's repugnance of the torture and ritual slaughter by the matador in actual bull fights which are close to being outlawed now in Spain.

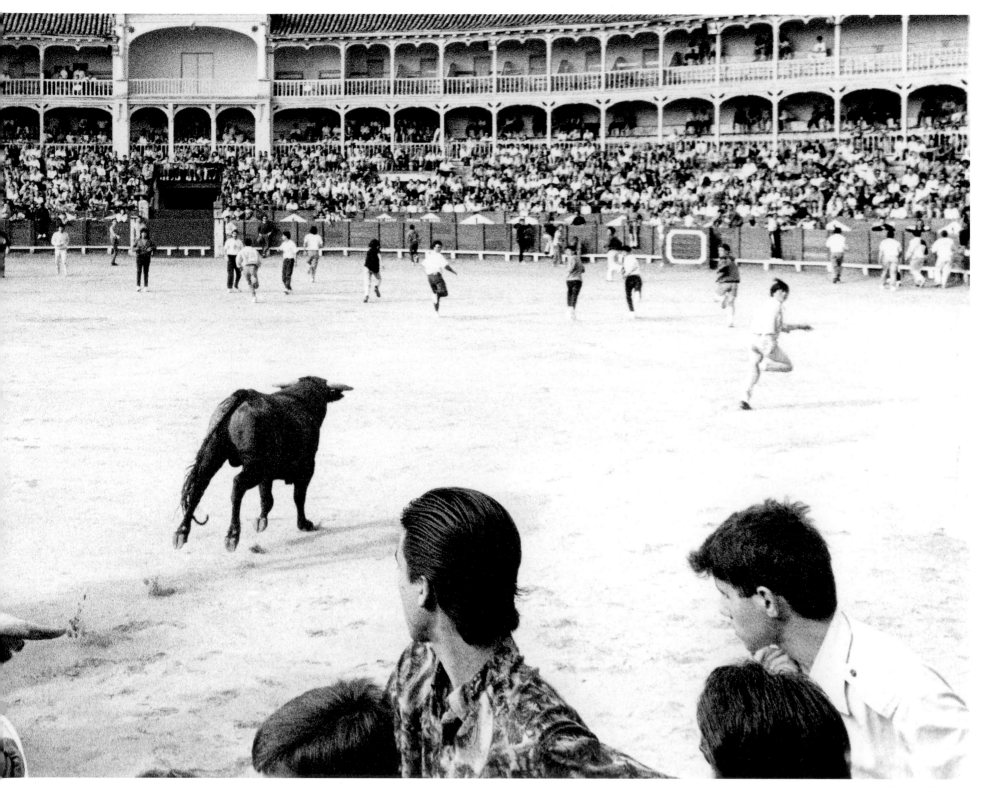

Aranjuez, Spain 1991

137

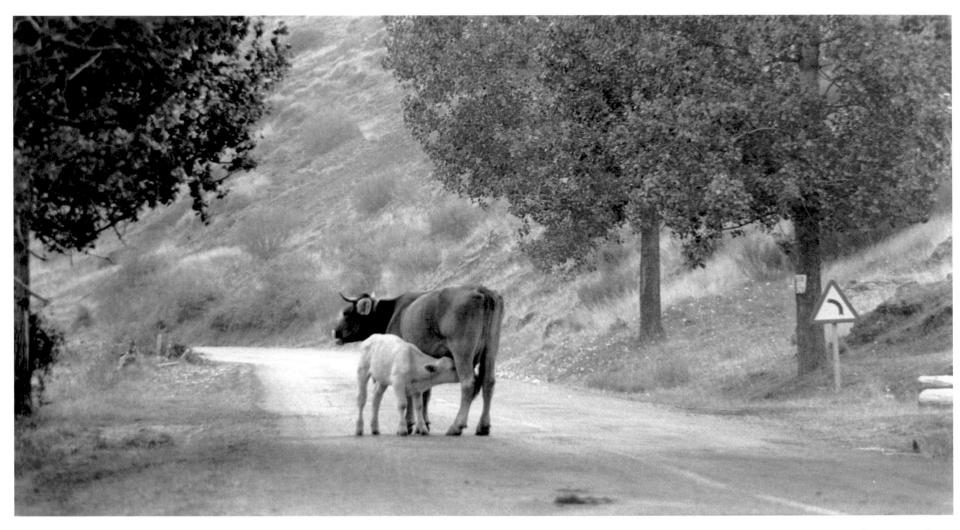

Cervera de Pesaguero, Spain 1991

Neither a car nor a camera will interrupt mealtime.
The photographer must approach on tiptoe.

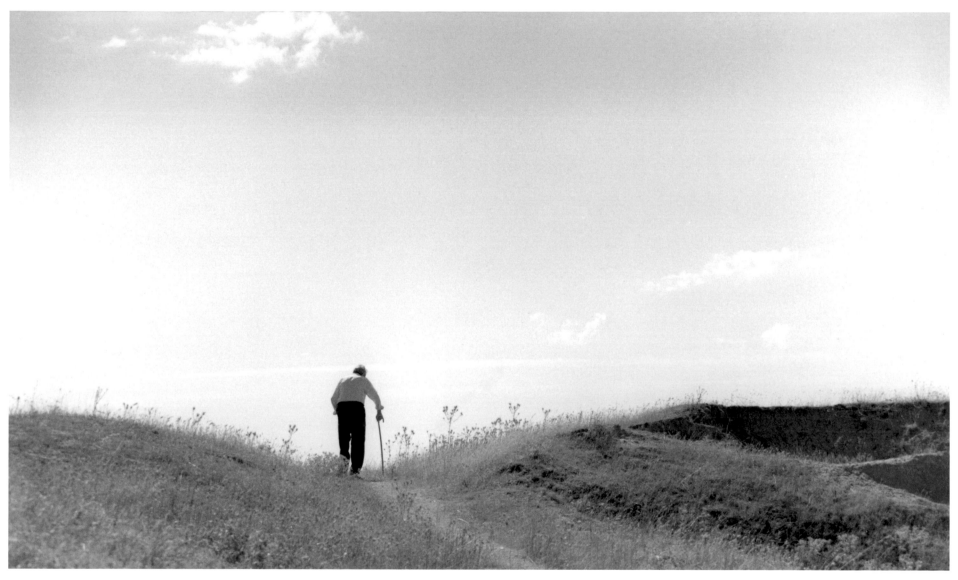

Villalon de Campo, Spain 1990

"La cara, no!" (My face, no!) but he allows a photo with his back turned.

And that turnaround makes for an even more interesting image.

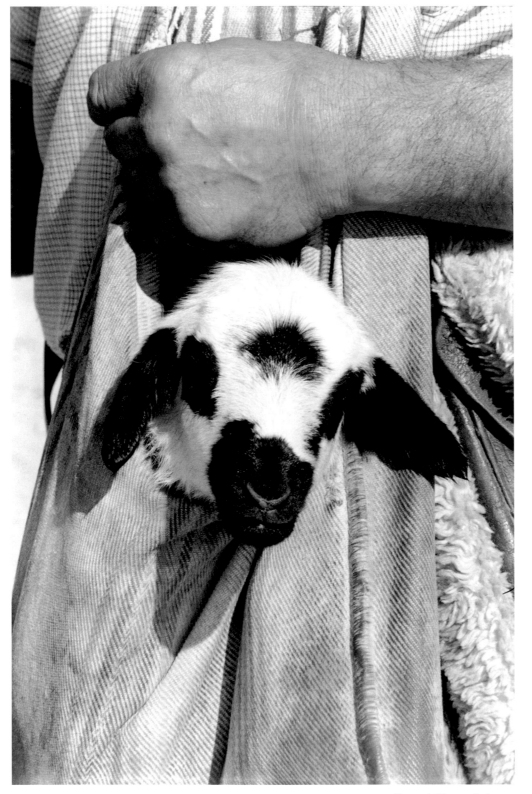

A brief stop by the wayside, both shepherd and kid accommodating the photographer, a momentary thief.

A portrait of textures: the coat of the shepherd and the soft hairy coat of the kid, carried out to suckle its mother while she is grazing.

Ventosa de Pisuerga, Spain 1990

The expression on a human face: an image made with compassion and pleasure.

Alas, the shepherd has no address, so the photograph cannot be sent to him.

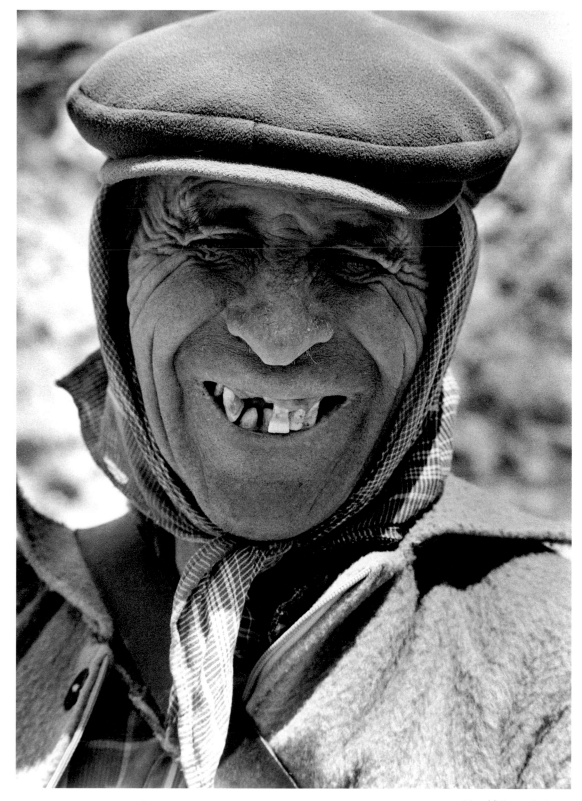

Moto del Cuervo, Spain 1991

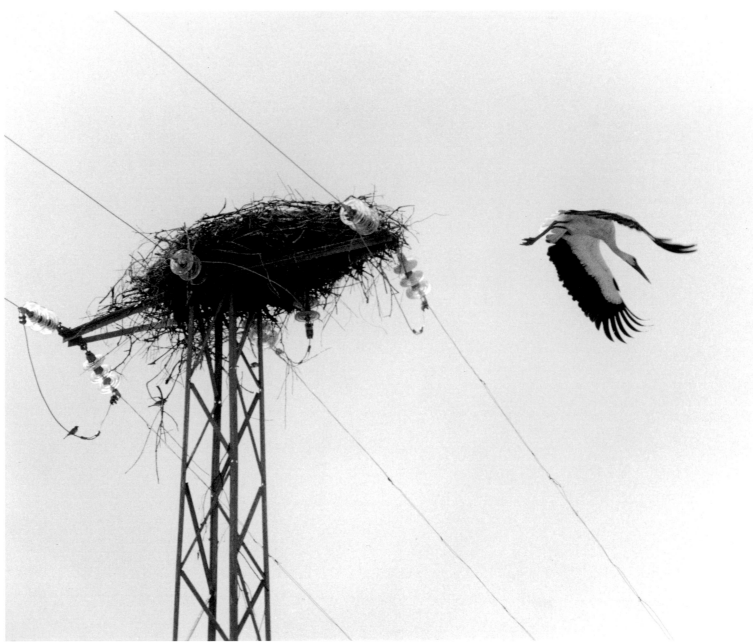

Caraboso, Spain 1998

"Jodías Ciguenas!" says an impatient travelling companion, as the photographer walks alongside the car for an hour and a mile, clicking again and again to find just the right moment. It takes as long as it takes.

The high voltage power lines are specifically designed to prevent electrocution (the most common cause of death to storks) so they can build their nests there. And two little birds are watching the liftoff, not noticed until the print was made.

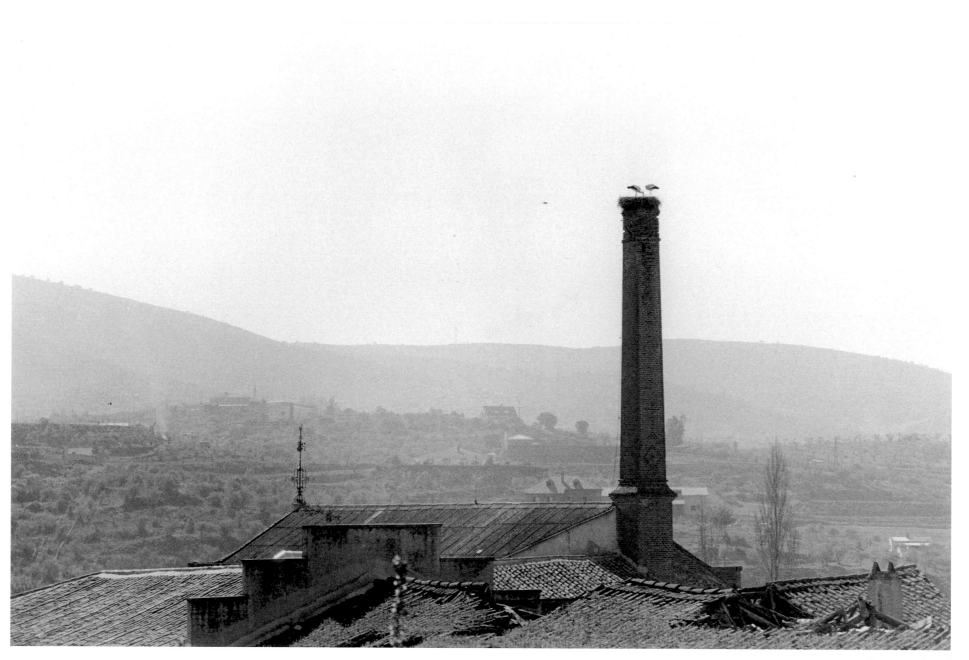

Placencia, Spain 1998

The storks appropriate the chimney, while the photographer appropriates the scene.

A pair of Alsatian white storks and their half ton nest have chosen prime real estate, overlooking the ancient city of Plasencia. Many make the arduous migration to Africa (via Turkey, Syria, Lebanon and Israel) but others remain for the easy food supply having lived here among their human protectors for centuries.

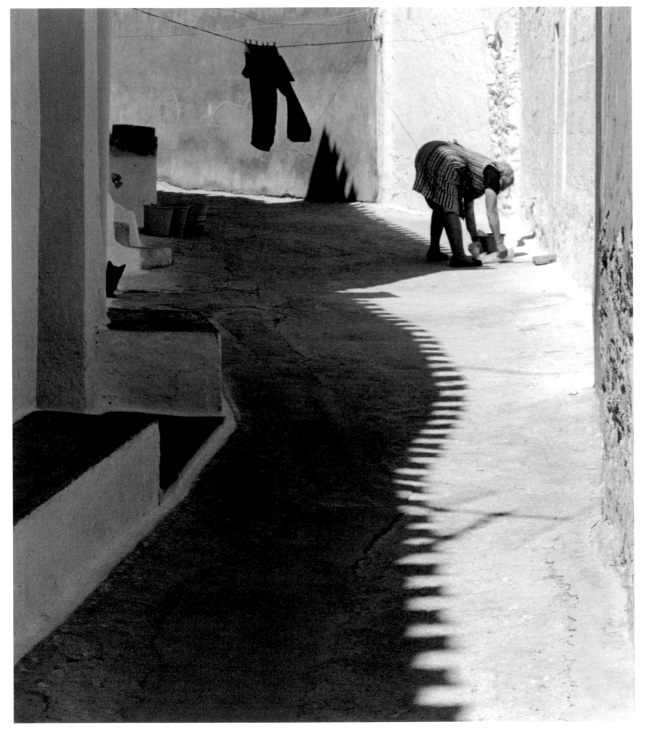

The delight of photography is the coming upon a "scene" made ready in that very instant.

And only later, in musing over the photographic print is one cognizant of the similarity of forms here: the cat's ears, the roof's edge, and the clothespins. Each street and home is carved into the mountainside overlooking the deep abyss of the river Júcar.

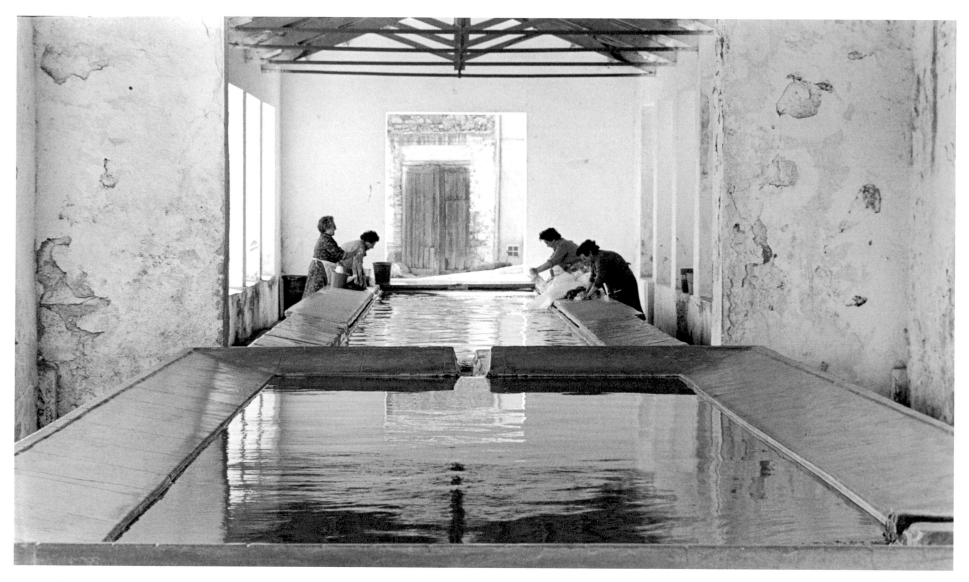

Alcala de Júcar 1991

Photography gives one an excuse to encounter surprises and bring them home.

A lavandería in a small town where clean, cold water from the mountains fills the tubs, and where the water and talk flow freely, uninterrupted by the camera.

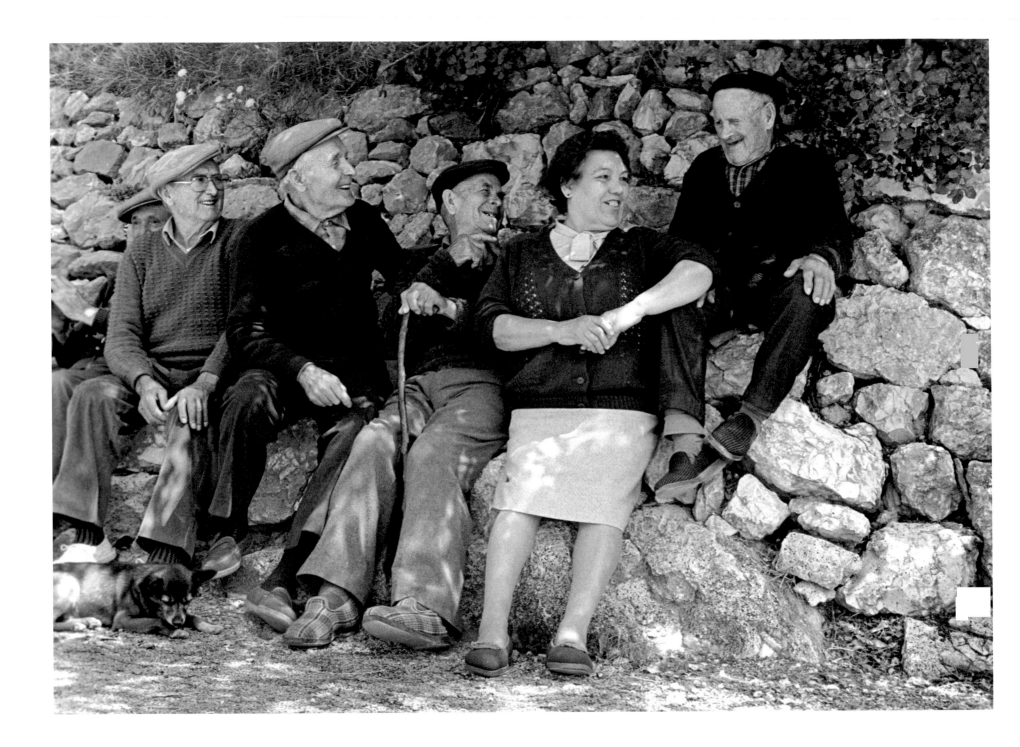

"*Sí. Make a foto, but hurry or I'll be over there (pointing to the small cemetery) before you send it.*" *The foto was sent pronto.*

Photography allows sharing, another pleasant aspect of the work.

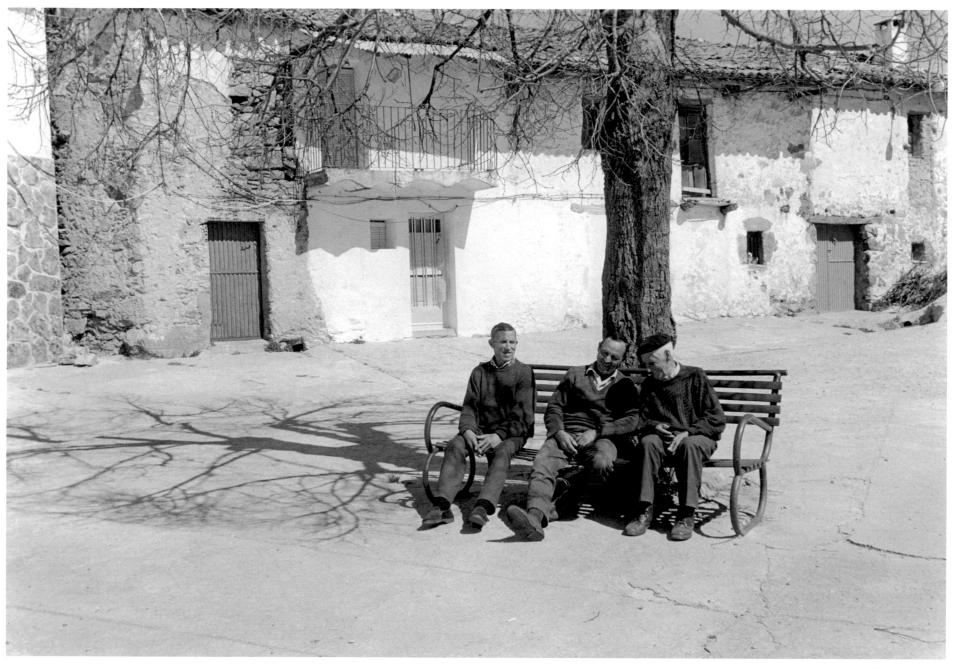

Piornal, Spain 1998

Shadows that lie about in the sun wait to be acquired by photographers who worship their evanescent forms.

147

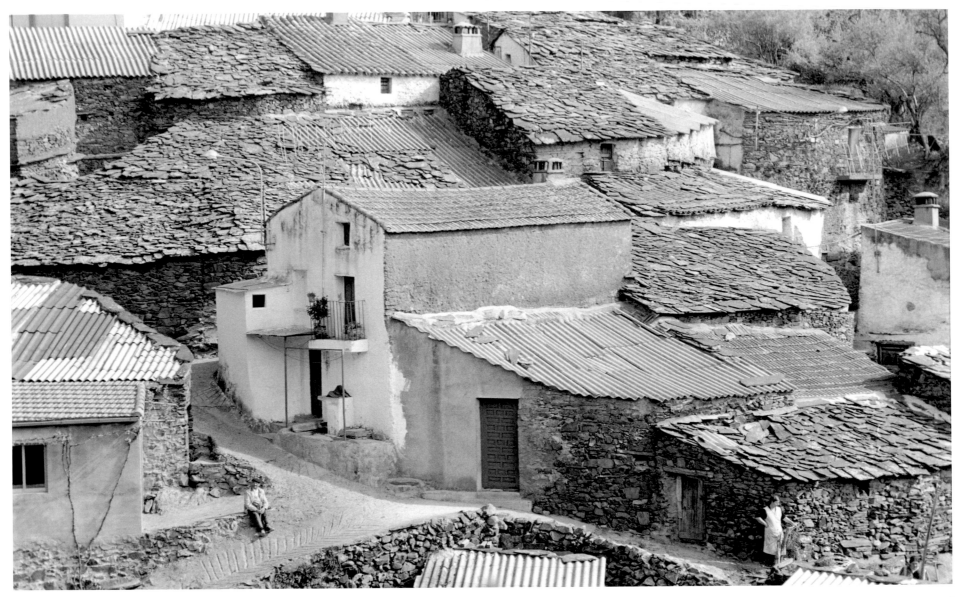

Asegur, Las Hurdes, Spain 1998

How to avoid feeling like a voyeur making photographs in the poorest area of Spain?

The photographer needs to spend sufficient time to get involved with the people and understand their circumstances. The comarca of Las Hurdes, in the far western part of Spain, was known as "the land without bread" where, in 1932, Luis Buñuel made his surrealist film Tierra Sin Pan about the terrible poverty of the Hurdanos. They eke out a living with food grown on terraces built up with local slate stones out of which their homes are also built.

148

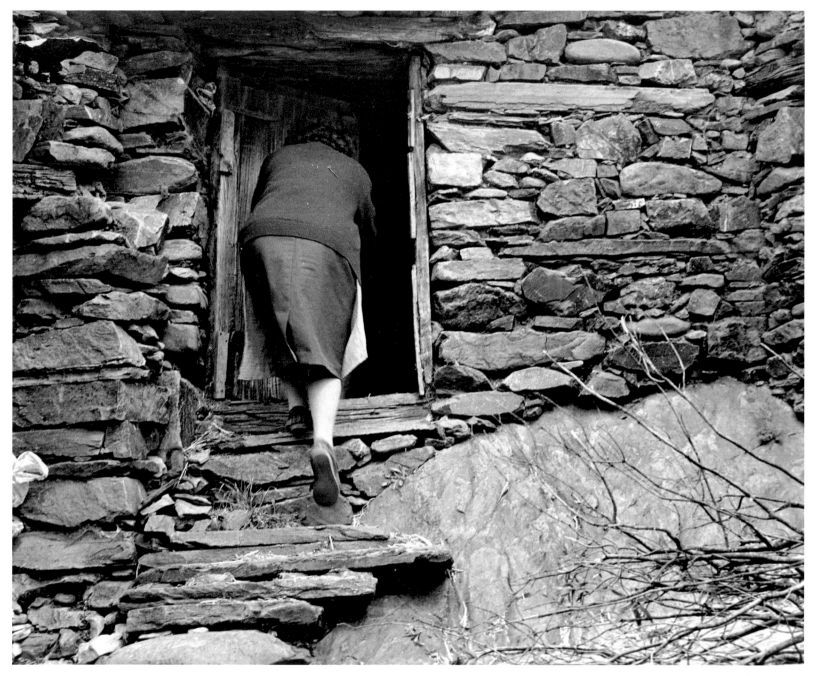

Asegur, Las Hurdes, Spain 1998

"Saca fotos, no! Poco lujo las casas!" (No photos! Our homes are very poor!) But the photographer has stolen this one while her back was turned.

Wanting a closer look at the simply built slate houses, one might need to make a hasty decision, and then live with the moral implications of a stolen image.

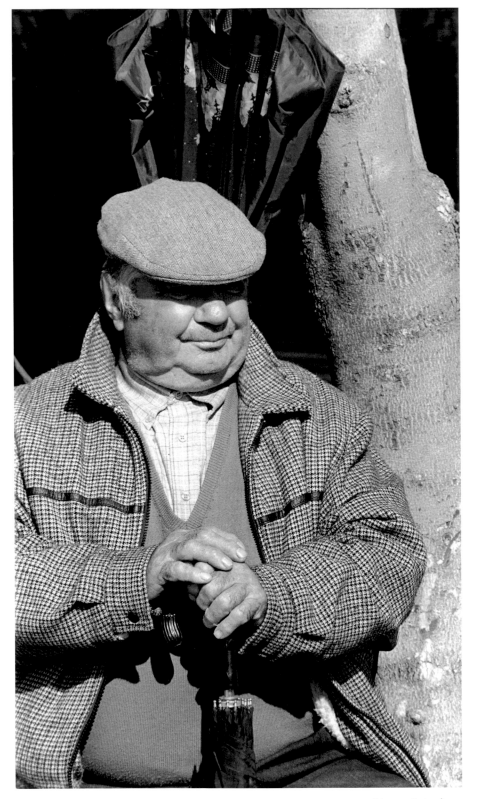

Estremoz, Portugal 2002

A personage needing to be photographed, just so.

Sitting in the open market, he is performing a public service for the photographer, who possesses the image, which can now be observed at leisure, discovering elements that were missed at the moment of capture.

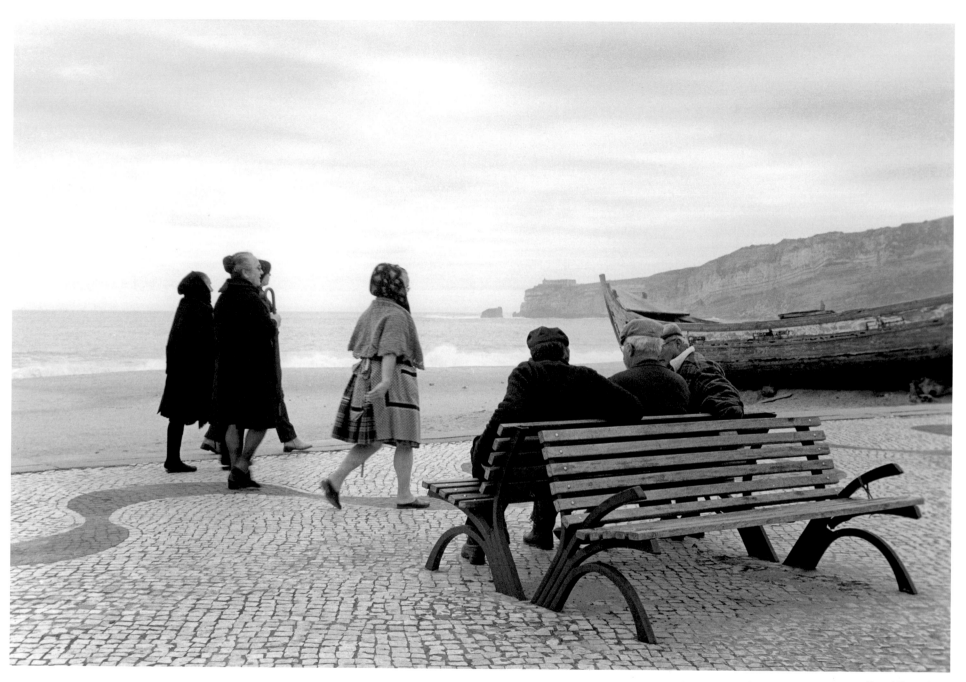

Nazaré, Portugal 2002

Quickly! The next 1/125 second will be too late!
The camera must always be ready.

A chance encounter provides a fortunate glimpse
of women in traditional dress in this fishing village.
The Portuguese make eye candy of their sidewalks.

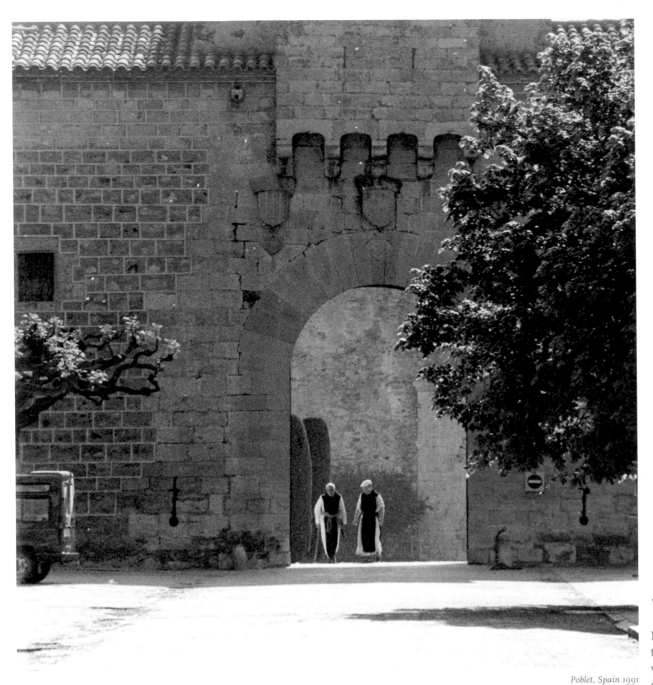

Poblet, Spain 1991

Waiting for something to happen often means it will.

Not yet there in the first exposure. Then, along come two monks illuminated by the late afternoon sun which gives them sharper outlines. A photographer's commandment: "Turn not thy back on the sun but look him full in the face."

The Cistercians are called the White Monks from their distinctive white habit, over which a black apron is sometimes worn.

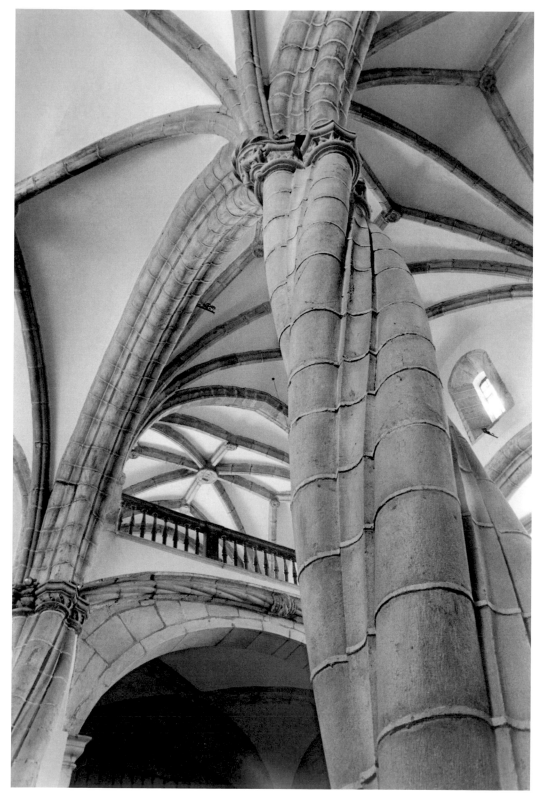

Olivenza, Spain 1998

Making oneself ridiculous can be part of the job of a photographer, who lies supine with camera on tripod and an extended shutter release in hand.

Making the photograph from this position dramatizes the powerful, alive thrust of the exuberant Manueline column. This decorative style, from the 16th century reign of King Manuel I, represents the exploits of the Portuguese navigators: ropes, anchors, seaweed and tropical plants.

BIBLIOGRAPHY

The following bibliography presents most of the material read, browsed or referred to while formulating this book. Most of these works are a part of my own library collection on photography, acquired over some 35 years.

Within the following list are a few which are of central importance, especially Jane M. Rabb's critical anthology *Literature and Photography: Interactions 1640 – 1990* which provides a context given the ideas, reflections, and stories of many artists. Others are Susan Sontag's *On Photography*, Fred Ritchin's *After Photography*, and Charles Swedlund's *Photography, A Handbook of History, Materials, and Processes.*

Other books deal with philosophical and historical matters. Some are biographical, several are photographic critiques and essays, and a few novels feature photography as a main theme. Also listed are books of the collections of the work of great photographers. And of course there are many which provide guidance in the technical methods of creating a photograph. Many photographers are "self taught" through books, before going on to master classes and joining critique groups with others who are similarly struggling to achieve something satisfying in the art.

But why is this reading feast relevant to my book? Let's say the photographer resembles a creative cook. She is preparing many meals from her repertoire for receptive and hungry friends. The culinary endeavor may be a solitary one but open to the ideas of others. She might consult talented chefs whose ideas resonate or stimulate, thus enriching her own work. And doing so helps the cook give her own recipes some perspective (which can often be quite humbling.)

Readers who browse this list will see how much photography has been thought and written about, how many collections of photographers' work have been reproduced in books, and how fascinating is the history of this new art, as photography has gone through many transformations in a relatively short time. Scanning that list one might also discover how stimulating and controversial photography has always been, an art that is playing an increasing part of so many aspects of life today.

The reader is encouraged to delve into any of these volumes for a better understanding and enjoyment of photography.

AUTOBIOGRAPHY & BIOGRAPHY

Auerbach, Ellen. Ellen Auerbach Berlin- Tel Aviv- London- New York (Prestel: 1998).

Bourke-White, Margaret with Erskine Caldwell. You Have Seen Their Faces (Viking Press: 1937).

[Brandt, Bill]. Bill Brandt: Photographs 1928-1983 (Thames & Hudson: 2007).

Frizzell, Deborah. Humphrey Spender's Humanist Landscapes:Photo-Documents,1932-1942 (Yale Center for British Art: 1997).

Galassi, Peter. Henri Cartier-Bresson: The Early Work (Museum of Modern Art: 1987).

Gordon, Linda. Dorothea Lange/ A Life Beyond Limits (W.W. Norton ; 2009).

[Kertész, André]. André Kertész: Of Paris and New York (Art Institute of Chicago: 1985).

_____. Kertesz on Kertész (Abbeville Press: 1983).

[Lange, Dorothea]. Dorothea Lange : Photographs of a Lifetime (Aperture: 1982).

Loengard, John. Pictures Under Discussion (Amphoto: 1987).

Man Ray (Aperture: 1979).

Morris, Wright. Time Pieces (Aperture: 1989).

_____. The Inhabitants Charles Scribner's Sons: 1946).

Newhall, Beaumont. Supreme Instants: The Photographs of Edward Weston (Little Brown: 1986).

Phillips, Sandra S. ed. Helen Levitt (San Francisco Museum of Art: 1991).

[Salgado, Sebastio]. Sebastio Salgado: An Uncertain Grace (Aperture: 1990).

Van Haaften, Julia. ed. Berenice Abbott, Photographer: A Modern Vision (New York Public Library:1989).

CRITICISM:

Appel, Jr., Alfred. Signs of Life (Alfred A. Knopf: 1983).

Barnett, Terry. Criticizing Photographs (Mayfield Publishing: 1996).

Barthes, Roland. Camera Lucida: Reflections on Photography (Noonday Press: 1981).

Bayer, Jonathan. Reading Photographs / Understanding the Aesthetics of Photographs (Pantheon Books: 1977).

Bellow, Saul. It All Adds Up (Viking/Penguin: 1995).

Beloff, Halla. Camera Culture (Basil Blackwell: 1985).

Benjamin, Walter. The Work of Art in the Age of Mechanical Reproduction (Illuminations Collection:1970).

Berger, John. Ways of Seeing (BBC Penguin Books: 1972).

Bloom, John. Photography at Bay (University of New Mexico Press: 1993).

Cartier-Bresson, Henri. The Mind's Eye: Writings on Photography & Photographers (Aperture: 1996).

Chalifour, Bruno. Photography Speaks/ 150 Photographers of Their Art (Aperture:2004).

Coleman, A.D. Tarnished Silver: After the Photo Boom / Essays and Lecture 1979-89 (Midmarch Arts:1996).

Cooper, Thomas & Paul Hill. Dialogue with Photography (Farrar, Straus & Giroux: 1979).

Dyer, Geoff. The Ongoing Moment (Pantheon Books: 2005).

Hockney, David. That's the Way I See it (Thames & Hudson: 2005).

Johnson, Brooks, ed. Photography Speaks: 76 Authors on Their Work (Aperture:1963).

Kazloff, Max. Lone Visions /Crowded Frame: Essays on Photography (University of New Mexico Press:1994).

_____. Photography and Fascination (Addison House: 1979).

Levi Strauss, David. Between the Eyes: Essays on Photography & Politics (Aperture: 2003).

Lyons, Nathan, ed. Photographers on Photography (Prentice-Hall: 1996).

Solomon-Godeau, Abigail. Photography at the Dock (University of Minnesota Press: 1991).

Somers, Robert. Rethinking the Forms of Visual Expression (University of California Press: 1990).

Sontag, Susan. On Photography (Noonday Press: 1973).

Trachtenberg, Alan. Reading American Photographs (Harper Collins: 1989).

_____. ed. Classic Essays on Photography (Leete's Island Books: 1980).

Willumson, Glenn Gardner. Eugene Smith and the Photographic Essay (Cambridge University Press:1992).

FICTION:

Keilson, Hans. Death of the Adversary (Farrar, Straus and Giroux: 2010).

Lively, Penelope. The Photograph (Viking Press: 2003).

Pérez-Reverte, Arturo. The Painter of Battles (Random House: 2006).

Shapiro, Dani. Black and White (Alfred A. Knopf: 2008).

Tournier, Michel. The Ogre (Johns Hopkins University Press: 1970).

HISTORY:

Benjamin, Walter. A Short History of Photography (Screen Magazine: Spring 1972 vol. 13 #1 pgs. 5-26).

Collins, Kathleen, ed. Shadow and Substance / Essays on the History of Photography (Amorphous Institute Press: 1990).

Crawford, William. The Keepers of Light/A History & Working Guide to Early Photographic Processes (Morgan & Morgan: 1979).

Dault, Gary Michael & Jane Corkin. Children in Photography/ 150 Years (Firefly Books: 1990).

Greenough, S., Travis, D., Snyder, J. On the Art of Fixing a Shadow (National Art Gallery & Art Institute of Chicago: 1989).

Newhall, Beaumont. The History of Photography (Little, Brown: 1982).

_____. The Latent Image / The Discovery of Photography (Doubleday: 1967).

Phillips, Christopher, ed. Photography in the Modern Era/ European Documents & Critical Writings 1913-1940 (Museum of Modern Art: 1989).

Rabb, Jane M. ,ed. Literature and Photography: Interactions 1840-1990 (University of New Mexico Press: 1995).

Ritchin, Fred. After Photography (WW Norton: 2009).

Sawdler, Martin. Against the Odds: Women Pioneers in the First Hundred Years of Photography (Rizzoli 2002).

Shloss, Carol. Invisible Light / Photography and the American Writer/1840-1940 (Oxford University Press: 1987).

TECHNICAL:

Adams, Ansel. The Negative (Little, Brown: 1981).

_____. Ansel Adams: Examples /The Making of 40 Photographs (N.Y. Graphic Society:1983).

Baldwin, Gordon. Looking at Photographs/A Guide to Technical Terms (J Paul Getty Museum: 1991).

Dorskind, Cheryl Machat. The Art of Hand Painting Photographs (Amphoto Books: 1998).

Seeley, J. High Contrast (Focal Press: 1992).

Swedlund, Charles. Photography/A Handbook of History, Materials, and Processes (Holt, Rinehart and Winston: 1974).

The Camera (Time-Life Books: 1981).

COLOPHON

Text set in the typeface FF Scala.

FF Scala is an old style, humanist, serif typeface designed by Dutch typeface designer Martin Majoor in 1990 for the Vredenburg Music Center in Utrecht, the Netherlands. The FF Scala font family was named for the Teatro alla Scala (1776–78) in Milan. Like many contemporary Dutch serif faces, FF Scala is not an academic revival of a single historic typeface but shows influences of several historic models.

Printed on the stock Phoenix Motion 115lb Xantur, a FSC certified stock. The pulp originates from well managed forests by the Scheuflin Mill, Lenningen, Germany.

The printing and binding is by Capital Offset Company, Concord, NH, www.capitaloffset.com.

This book was designed by Karen Stein, Boston, MA, www.goodgoodland.com.

Created in InDesign CS5 and Photoshop CS5.